MW01148613

The Infernal Bestiary

Matthieu Hackière
Justine Ternel

GINGKO PRESS

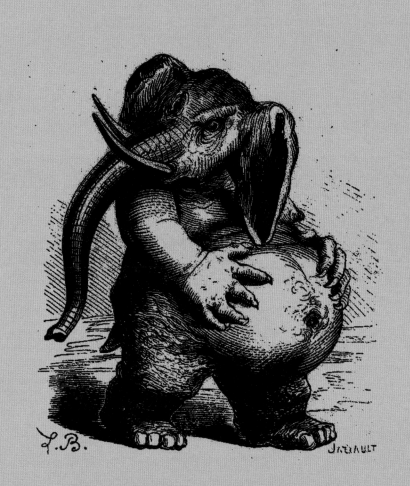

Interview with Matthieu Hackière

Matthieu, could you please describe your artistic background.

I went to Doornik, in Belgium where I studied graphic arts at the Saint Luc Institut. Then, still in Doornik, I entered the school of fine arts where I specialized in graphic design.

These were years of freedom: artistically and personally I learned much but I also quickly realised that I wasn't interested in the jobs I was being trained for...

However, during those years I met friends and teachers who widened my artistic view. After different commands – logos, posters, record sleeves and exhibitions – I realised that my desire to make books was getting bigger and bigger. So I decided to give it a try! I worked hard and released my first book in 2010, *Macchabée Strips*, published by Ankama Editions. I go on today in making what I love the most with the release of *The Infernal Bestiary*.

Can you tell us a little bit about the original *Dictionnaire Infernal* from 1818? As far as we know it includes more than just articles about beasts and monsters...

When I first decided to realise an infernal bestiary I started looking for documents. I had the idea of making that kind of inventory before my path met the *Dictionnaire Infernal*.

Through my wandering on the web, I found very few relevant documents on the mythologies I was interested in... Then after long hours lost on mystic blogs and websites I finally found the *Dictionnaire Infernal* by Jacques Collin de Plancy.

It is still possible today to find updated copies of this dictionary but they are rarely complete versions and some illustrations are missing. Though you can find the original version on Gallica, the French national digital library. That's the version I worked with! Everything was in there! In that 150-year-old book! It collects all the knowledge of that time on superstitions, beliefs, historical characters – real or not – and demonology! I just had to dive into it and to enjoy myself drawing what I thought was interesting for my book! The hardest part was to make decisions, to chose some creatures among others... There are still so many of them to illustrate!

What inspired you to work with the *Dictionnaire* from 1818? What makes the beasts and demons relevant today, 200 years after its original publishing date?

I believe that mankind has always found it exciting to create its own fears. Making up scary creatures, gods and devils, fantastic stories is a shared tradition in every human society. Today still, the number of movies, comics, serials, novels… shows that the subject is an unlimited resource. Whether it is new myths or ancient ones, this seems to be an endless universe.

I belong to those people who love scary stories! And being able to tell stories myself, to look for their origins and best of all to make them mine and to picture and to draw them has been a great pleasure!

To what extent are your images inspired by the original ones? Some seem to be very close to the original etchings, like Andras; some seem to be interpreted more freely, like Byleth for example.

Sometimes the illustrations shown in the dictionary, drawn by M. L. Breton and engraved by M. Jarrault, are so stunning that it seemed to me impossible to go in a different direction. I have just tried to dust off the picture, to keep its own nature and to stay in the mood of its time of creation. For some others, because all creatures aren't represented in the *Dictionnaire*, I just read the definition and a picture came to my mind instantly. I knew what to do and how I wanted to do it.

How do you create the images? What techniques do you use?

I use the same process for each illustration. I draw everything with a pencil on a hot pressed paper which is 30 x 30 cm and 300 g/m². Once the drawing is done, I scan it and do the colors on the computer.

What other influences do you have?

They are so many! And with the web today, we can find wonderful artists every day!

Okay, I'll try to stay focused on the ones who followed me from the beginning and through the whole *Bestiary*. Well, my favorite classic ones are Bruegel, Bosch and Goya. Those artists never leave me. I have also followed the work of Femke Hiemstra and Laurie Lipton for quite a long time now. While working on the *Bestiary*, I discovered three comics whose universes talk to me and which are incredibly well drawn: *Les ogres-dieux* by Hubert and Gatignol, *Satanie* by Vehlmann and *Kerascoet* and *Le Paradis Perdu* by Pablo Auladell.

Finally, I can't work without music and three of the artists I listened to the most during the making of the *Bestiary* are The Reverend Beat-Man, DAAU (Die Anarchistische Abendunterhaltung) and Josef van Wissem!

previous page:
Illustration of Behemoth by M. L. Breton for the 1863 edition of the *Dictionnaire Infernal*.

Paradise Lost

'Is this the region, this the soil, the clime,'
Said then the lost Archangel, 'this the seat
That we must change for Heaven? – this mournful gloom
For that celestial light? Be it so, since he
Who now is sovereign can dispose and bid
What shall be right: farthest from him is best
Whom reason hath equalled, force hath made supreme
Above his equals. Farewell, happy fields,
Where joy for ever dwells! Hail, horrors! hail,
Infernal world! and thou, profoundest Hell,
Receive thy new possessor – one who brings
A mind not to be changed by place or time.
The mind is its own place, and in itself
Can make a Heaven of Hell, a Hell of Heaven.
What matter where, if I be still the same,
And what I should be, all but less than he
Whom thunder hath made greater? Here at least
We shall be free; th' Almighty hath not built
Here for his envy, will not drive us hence:
Here we may reign secure; and, in my choice,
To reign is worth ambition, though in Hell:
Better to reign in Hell than serve in Heaven.
But wherefore let we then our faithful friends,
Th' associates and co-partners of our loss,
Lie thus astonished on th' oblivious pool,
And call them not to share with us their part
In this unhappy mansion, or once more
With rallied arms to try what may be yet
Regained in Heaven, or what more lost in Hell?'

So Satan spake; and him Beelzebub
Thus answered: – 'Leader of those armies bright

Which, but th' Omnipotent, none could have foiled!
If once they hear that voice, their liveliest pledge
Of hope in fears and dangers – heard so oft
In worst extremes, and on the perilous edge
Of battle, when it raged, in all assaults
Their surest signal – they will soon resume
New courage and revive, though now they lie
Grovelling and prostrate on yon lake of fire,
As we erewhile, astounded and amazed;
No wonder, fallen such a pernicious height!'

He scarce had ceased when the superior Fiend
Was moving toward the shore; [...]
Nathless he so endured, till on the beach
Of that inflamed sea he stood, and called
His legions – Angel Forms, who lay entranced
Thick as autumnal leaves that strow the brooks
In Vallombrosa [...] So thick bestrown,
Abject and lost, lay these, covering the flood,
Under amazement of their hideous change.
He called so loud that all the hollow deep
Of Hell resounded: – 'Princes, Potentates,
Warriors, the Flower of Heaven – once yours; now lost,
If such astonishment as this can seize
Eternal Spirits! Or have ye chosen this place
After the toil of battle to repose
Your wearied virtue, for the ease you find
To slumber here, as in the vales of Heaven?
Or in this abject posture have ye sworn
To adore the Conqueror, who now beholds
Cherub and Seraph rolling in the flood
With scattered arms and ensigns, till anon

His swift pursuers from Heaven-gates discern
Th' advantage, and, descending, tread us down
Thus drooping, or with linked thunderbolts
Transfix us to the bottom of this gulf?
Awake, arise, or be for ever fallen!'

They heard, and were abashed, and up they sprung
Upon the wing, as when men wont to watch
On duty, sleeping found by whom they dread,
Rouse and bestir themselves ere well awake.
Nor did they not perceive the evil plight
In which they were, or the fierce pains not feel;
Yet to their General's voice they soon obeyed
Innumerable.

(Excerpt from John Milton's poem *Paradise Lost* from 1667.)

The Infernal Bestiary

Abracax

Aegipans

Amdusias

Amon

Andras

Baal

Beelzebub

Behemoth

Beleth

Botis

Caim

Cerberus

Dagon

Deumus

Devaux

Dindarte, Marie

Empusa

Erlik-Khan

Eurynomos

Flauros

Forcas

Forneus

Foxes

Furfur

Gamigin

Gantiere

Garnier, Gilles

Glasya-Labolas

Gontran

Haagenti

Haborym

Halphas

Hecate

Incubus

Ipos

Iwangis

Jack

Jezebel

Kantius of Silesia

Kerikoff

Kisilova, The Vampire of

Kraken

Leshy

Leonard

Leviathan

Lucifer

Malphas

Marchosias

Martibel, Sarena

Monsieur de Laforet

Naberius

Necato

Nybbas

Nyol

Olivier

Orobas

Phenex

Piletski

Puck

Purson

Raollet, Jaques

Raum

Rübezahl

Satan

Secretain, Françoise

Sitri

Stolas

Tikbalang

Uanna

Ukobach

Valac

Valefar

Vapula

Vepar

Vual

Yetzer-Tov, Yetzer-Hara

Zaebos

Zagan

Abracax

For the Basilidians, members of an 11th-century Gnostic sect in Egypt, Abracax was the symbol representing all levels of Heaven and the 365 related virtues corresponding to each day of the year. Others venerated him as a supreme god while Christians considered him a crowned demon and a king in Hell's aristocracy.

Do not underestimate this beast with a rooster's head – a glance at his serpent feet and the whip he brandishes is proof enough of his power!

His name may have also inspired the famous incantation "Abracadabra!"

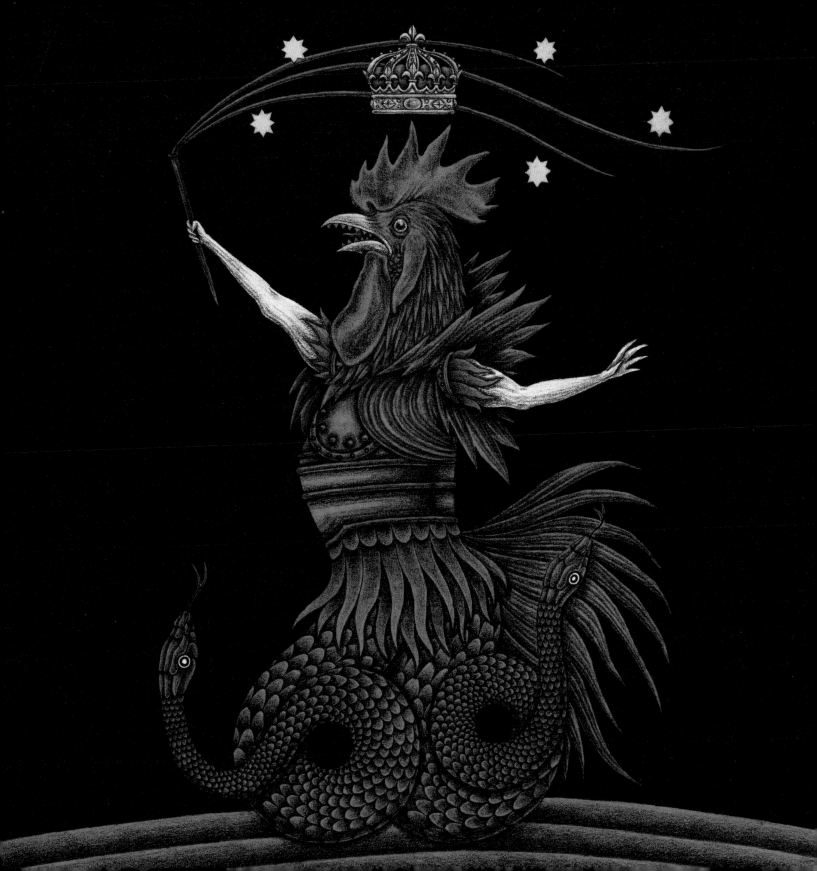

Aegipans

One of antiquity's pastoral divinities, the Aegipans look like furry men with horns and goats' feet.
They are similar to satyrs or fauns, and obviously to the god Pan, protector of shepherds and flocks.
The Aegipans are sometimes depicted as Chimeric creatures, similar to the Capricorn of the Zodiac
with a goat's head and torso and the tail of a fish, but also sometimes half-lion, half-fish.

12

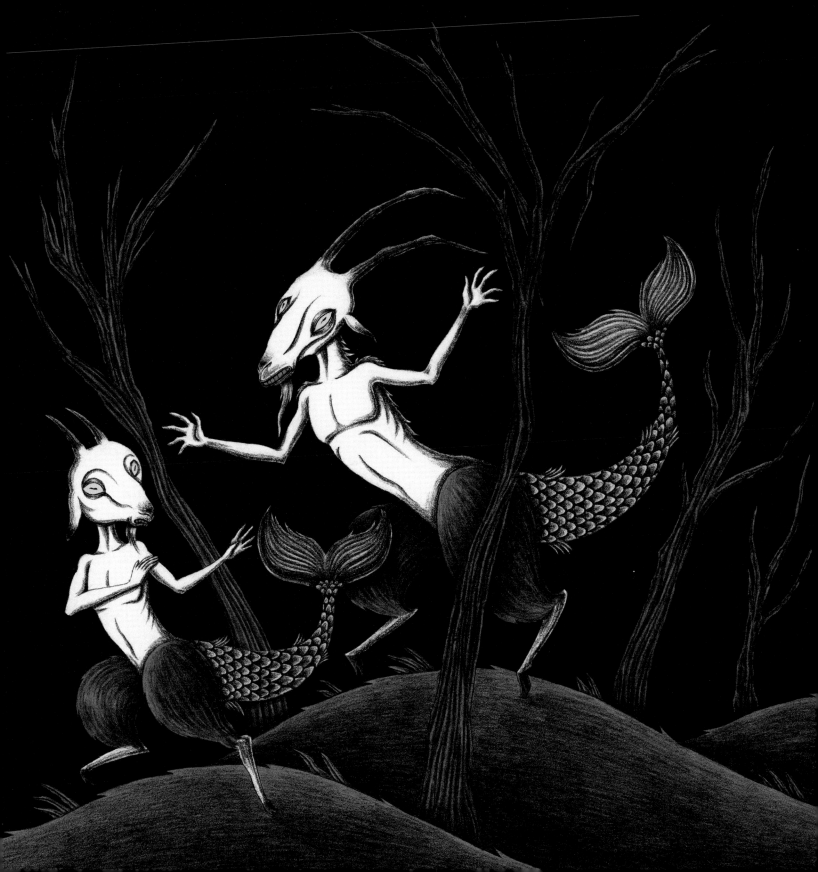

Amdusias

With his 29 legions of evil spirits, Amdusias is one of Hell's grand dukes.
This unicorn-headed demon directs the trumpets and brass instruments which herald certain
demonic events. Trees will even bow down at the sound of his music, foretelling his arrival.
Amdusias will appear in human form if he is summoned, but he also knows how to make himself
invisible, leaving only the sounds of his demonic concert in his wake.
He loves spreading false ideas, festering bias, and tormenting the weak spirits he possesses.

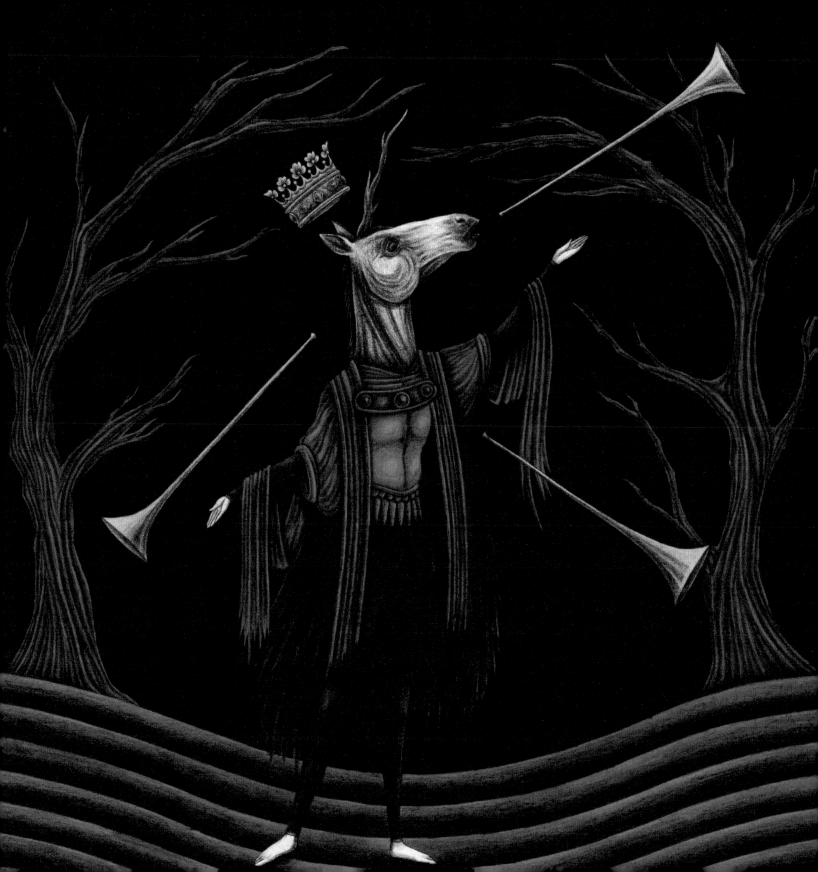

Amon

Amon is a powerful marquis of the underworld, but also the toughest of the demon princes.
The only part of him that appears human is the trunk of his body, which is completed by a serpent's
tail and a wolf's head spewing flames.
Amon has the power to reunite friends or confuse both friends and enemies. He can read the past
and foretell the future.
He shares a name with the Egyptian god Amon, but his own origins are unclear. He may also be a
part of the foundational myths of werewolfism.

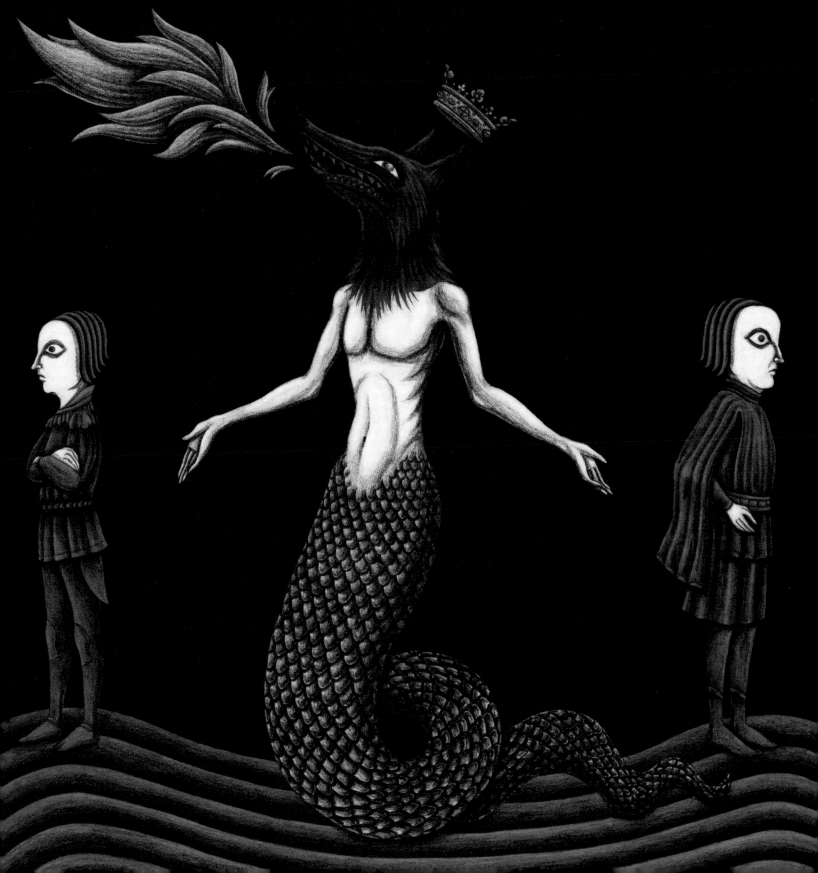

Andras

Andras is a marquis in the infernal aristocracy. He wields a sharp sword and rides a powerful black wolf, representing destruction and annihilation, while his owl's head is an ominous symbol of the inescapable reality of death.
Andras is a demon of crime and greed: he empowers humans to kill their enemies, sows discord, and destroys generous souls.

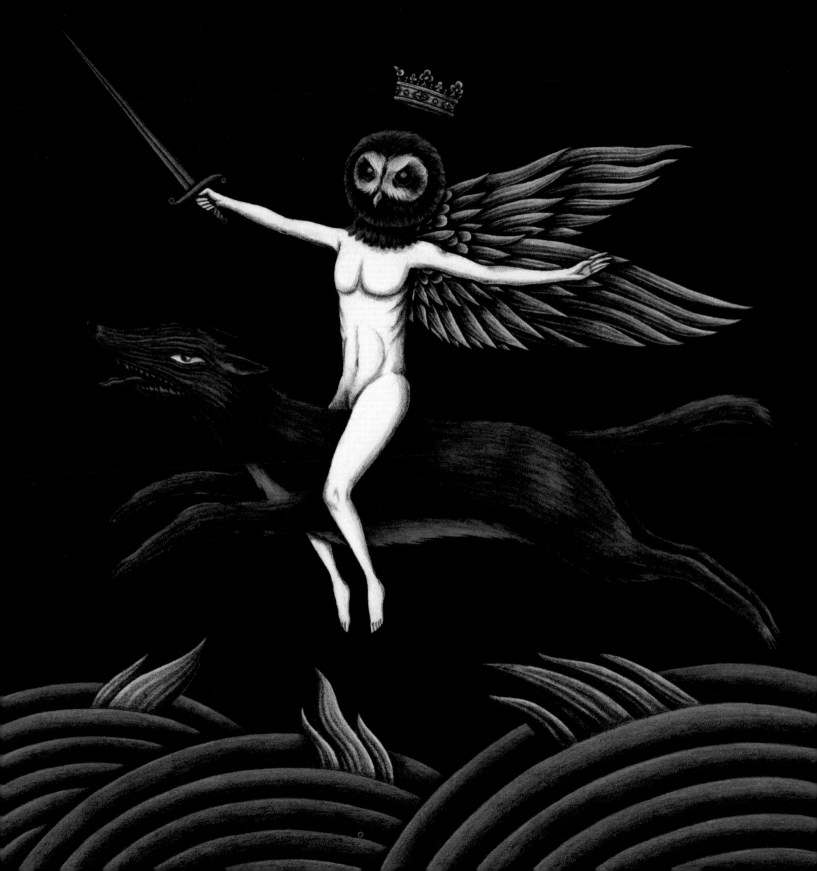

Baal

Baal is referenced in the 18th-century magical textbook, the *Grand Grimoire*, which contains a list
of demons and is still housed at the Vatican today.
Baal is a great warrior, and also the highest ranked king in Hell's aristocracy. A demon with a raspy
voice and three heads: a man, a cat, and a toad. Both the cat and the toad are symbols of death: Baal
is a funereal demon. His body is propelled by spider legs.
To those who summon him he offers invisibility and cunning.

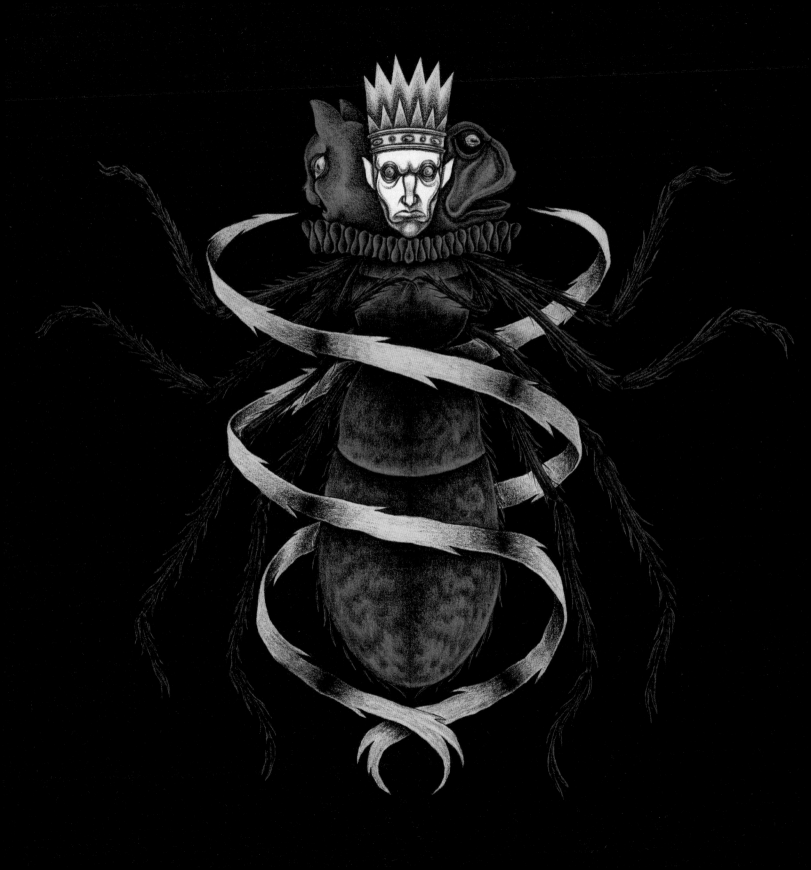

Beelzebub

Beelzebub is a demon with multiple origins and stories. Slipping from one status to another, he is sometimes a venerated pagan god of the harvest and other times a prince of demons. To play his beloved tricks on humans, he will take a mortal form as either a man or a woman. He is one of the most powerful of the fallen angels, ranked just behind Satan in the hierarchy of demons, making him their chief overlord. He is an emperor of 666 infernal legions.

Frequently called the King or the Lord of the Flies, he can take this form and has black skin, lively, clever eyes and a head crowned in flames.

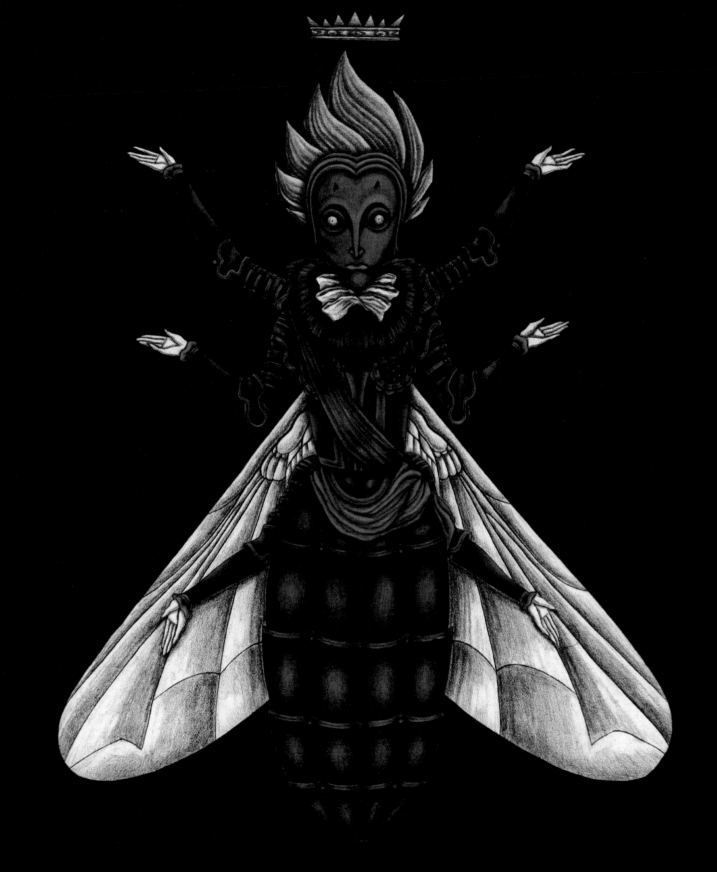

Behemoth

Behemoth is described in many different ways and found in numerous mythologies. In Hebrew, Behemoth means "the largest, most powerful earth creature" and is represented as an elephant, a hippopotamus, or even a whale. He takes the shape of the untamed animal, a beast that humans cannot domesticate.

By his size and power, he could be a symbol of Satan himself.

Yet Behemoth doesn't seem to be aggressive. He is happy to spend his days grazing on the grasses that cover the legendary thousand mountains.

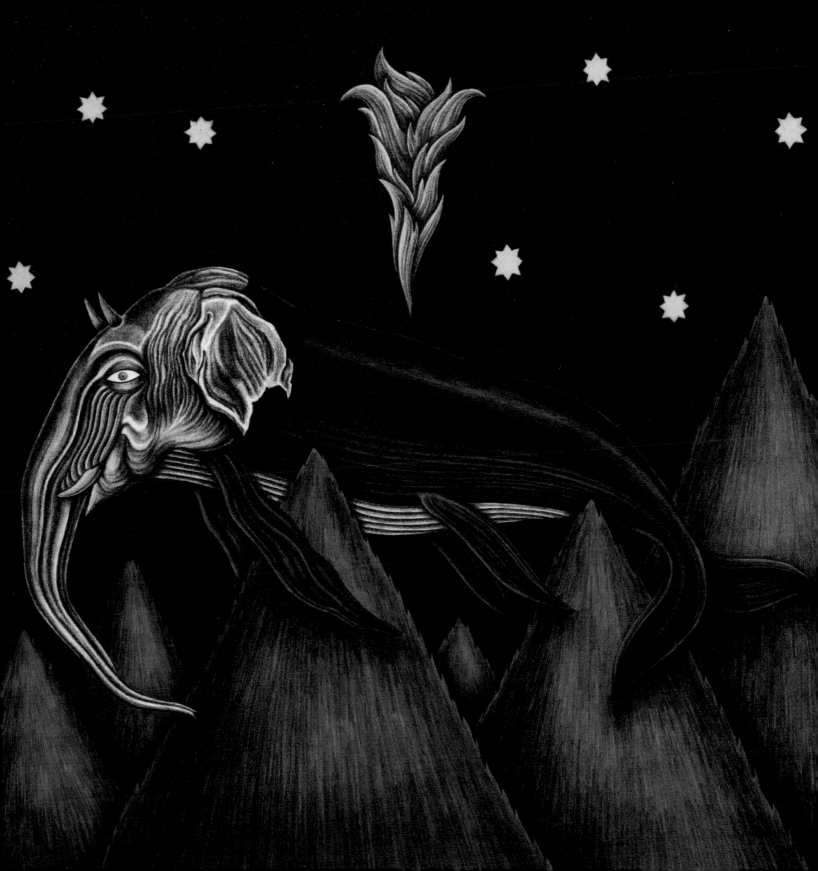

Beleth

Beleth is one of the kings of the underworld. He is strong and terrible.
Beleth is summoned during mystical incantations, appearing on a white horse and preceded by
trumpet-playing cats. Summoning him is risky, as he only obeys with wrath and his changing moods
must be monitored carefully. In order to control him, one must carry a hazel switch, flatter his
appearance, and quench his thirst with wine. Thus doing, the demon can grant incredible power to
the one who has called him forth.

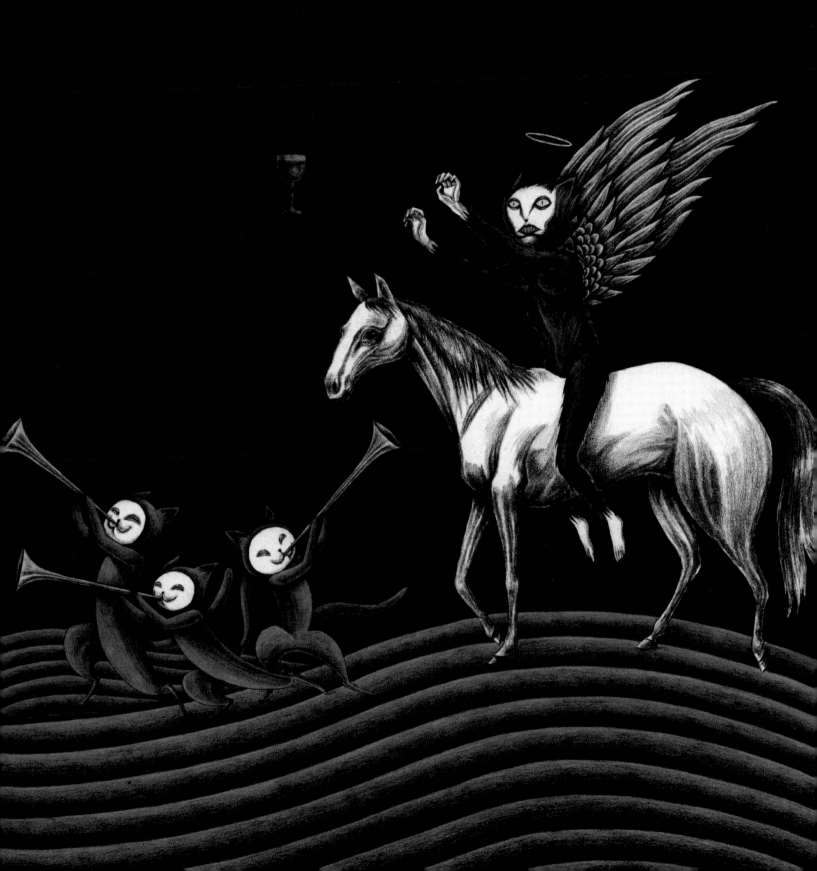

Botis

The demon Botis is a president of the underworld. A provocative and powerful demon, she spreads atheism throughout the world.

Botis appears in the form of a terrible viper with sharp teeth. She can also take human form, and when she does she has two horns and carries a sword that is sharp and blazing.

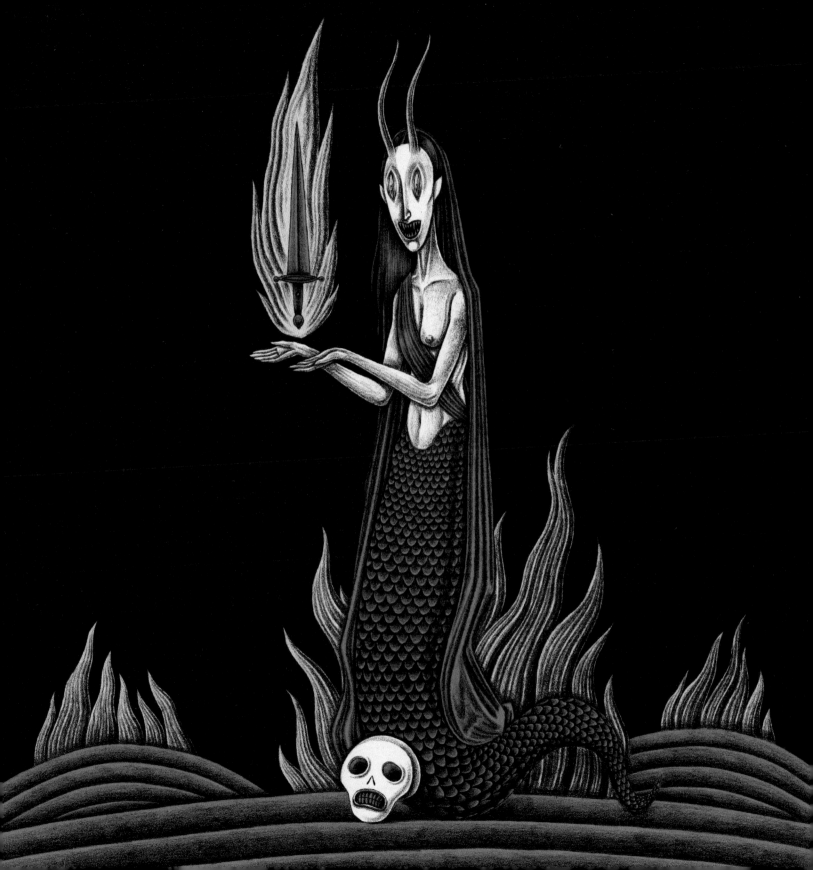

Caim

Caim is a high-ranking demon and a president of the underworld. He is famous for his fights with Lucifer.

A fallen angel, he is often represented as a blackbird and like this creature he is an expert singer, but he also knows how to moo like a cow, bark like a dog, or gurgle like rushing water. He is the most cunning of Hell's sophists and can exhaust the most gifted of orators.

Although Caim is a powerful demon, he is afraid of serpents. When he takes human form, he often appears amidst a blazing fire and holding a slender sword.

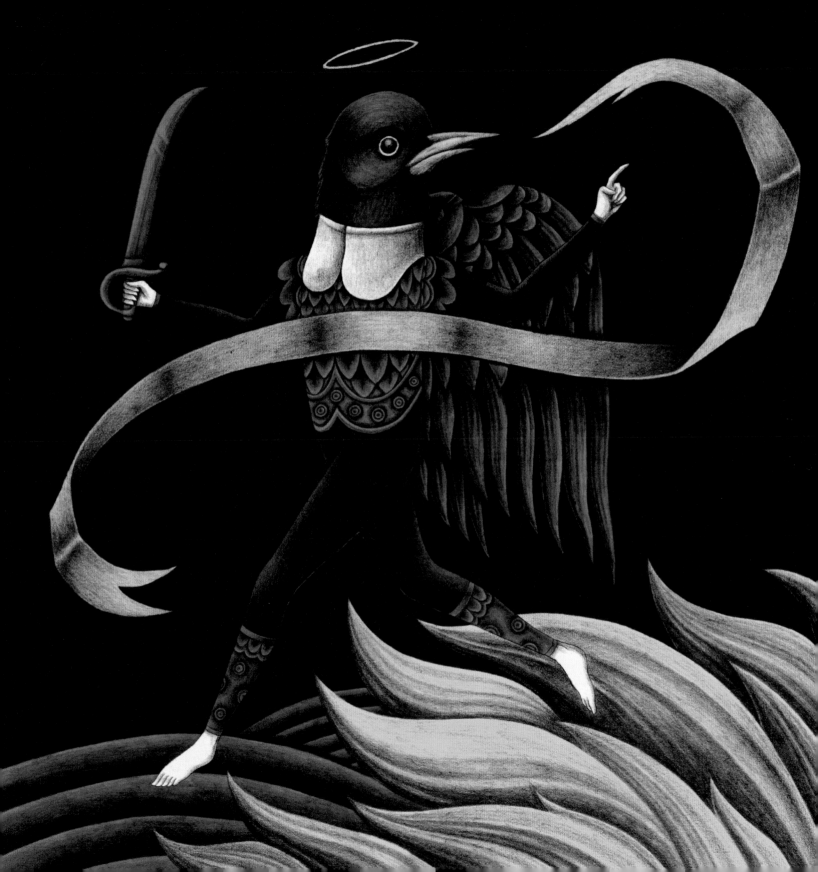

Cerberus

Cerberus has sometimes been represented as a crow, or crowned with a thousand serpents, but this major demonic figure is mostly known as the famous three-headed dog, guardian of the gates of Hell. As a dog he is a symbol of faithfulness and protection: first to Satan, and then of Hell. His legend appears to date to the Egyptians who used large dogs to guard their tombs.
Cerberus terrorizes both sides of the doorway, preventing the dead from escaping and the living from entering Hell to retrieve a long-lost loved one. It is said that his teeth are black and jagged and his bite causes sudden death.
In Greek mythology, his three heads symbolize the past, the present, and the future.

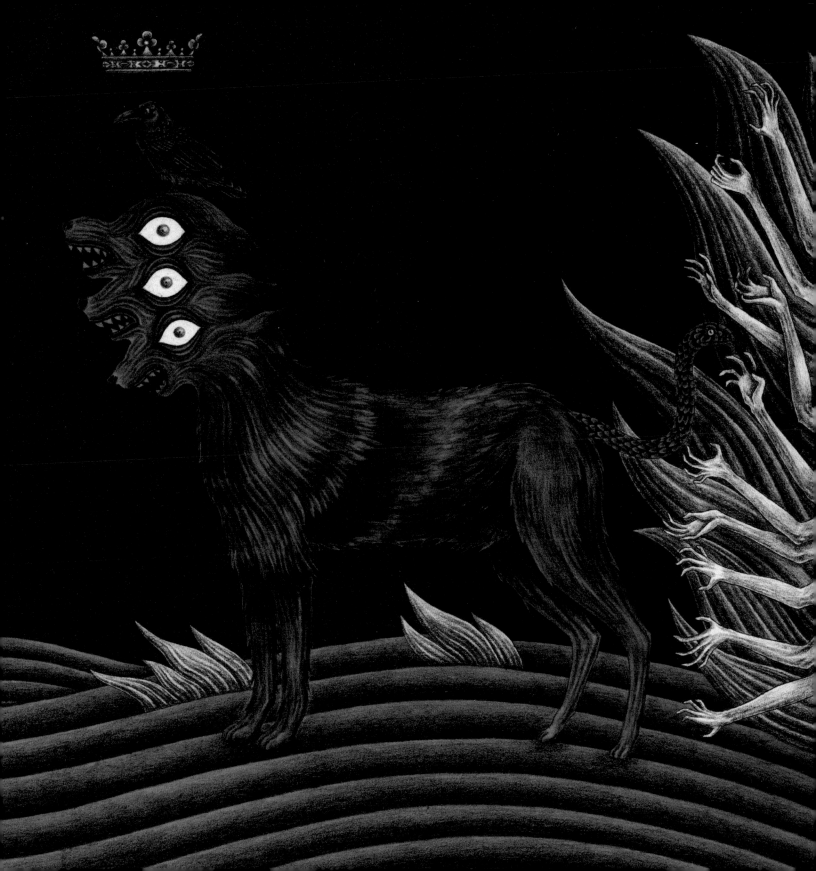

Dagon

Hell's baker, this Middle Eastern god is a second-rank demon. He is credited with inventing agriculture and was worshipped by the Philistines as the God of seed and grain. He is often depicted with a fish's head or body and this is certainly because of the geographical origins of the Philistines: a coastal people, fish was their daily sustenance.

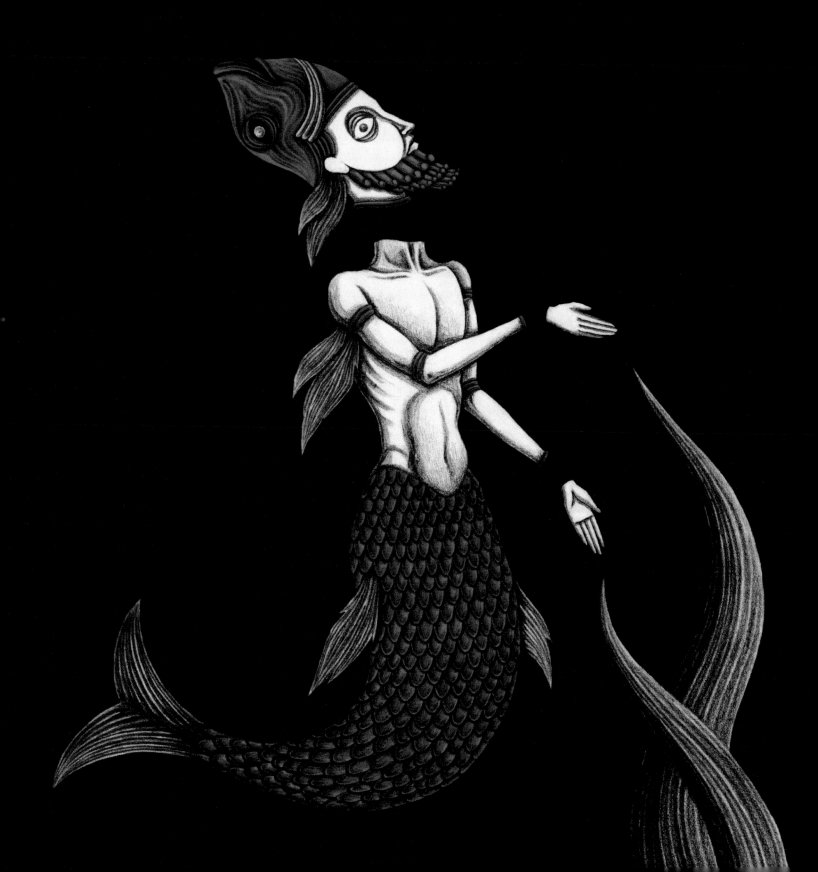

Deumus

Deumus is a god from western India with a pointed, beaked nose. He stands on rooster legs and has four horns on his head. His four large teeth are razor-sharp and merciless. He is an aggressive demon who devours lost souls, ripping them apart with his claws.

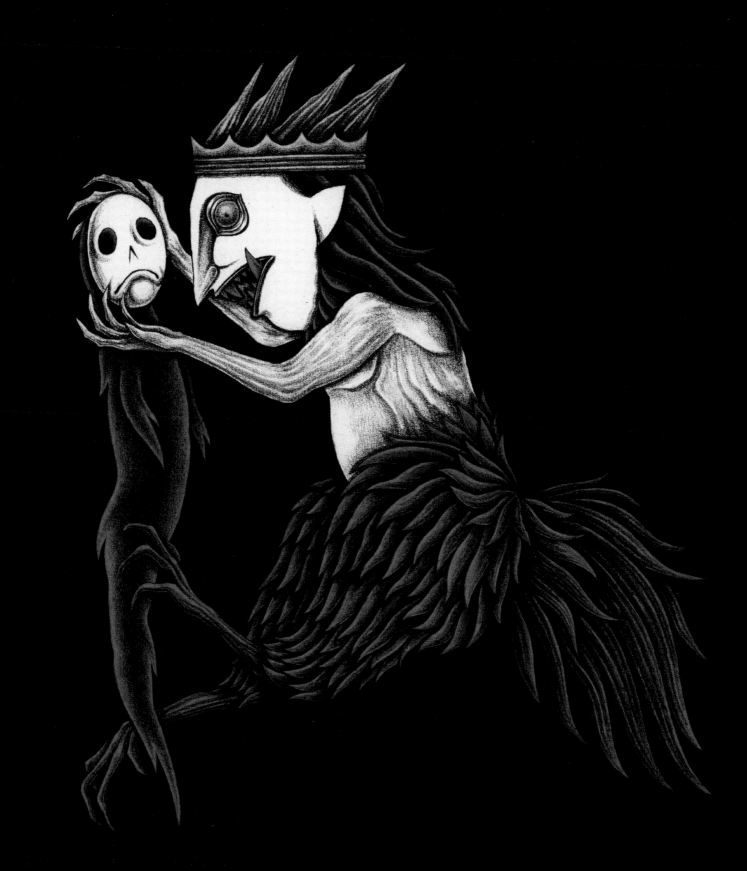

Devaux

Devaux was a sorcerer from the 16th century with a scar on his back in the shape of a black dog. To confirm his diabolical nature, men were asked to place needles in his scar tissue and when he did not react, proving that he felt no pain, he was denounced and condemned for sorcery.

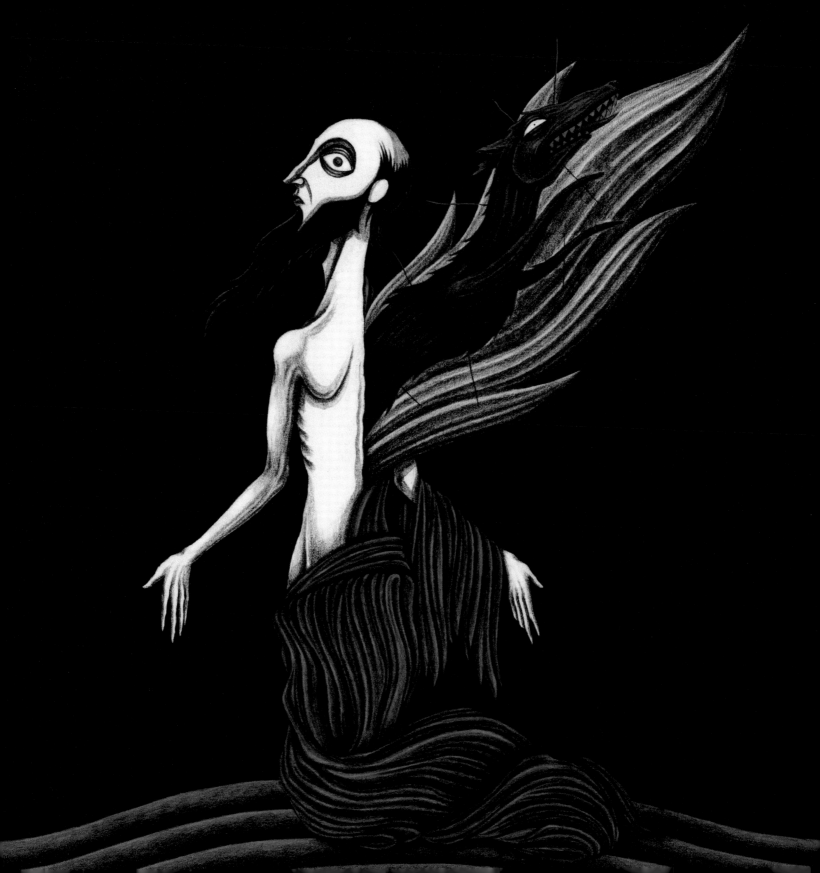

Dindarte, Marie

A young witch from the Lower Pyrenees, Marie Dindarte flew through the air after rubbing her body with an ointment that the devil himself gave her. This is how she traveled through the night of September 27, 1609 and was captured and condemned for sorcery. She admitted to having lead children to the witches' midnight sabbath of ceremonies, banquets, and sacrifices.

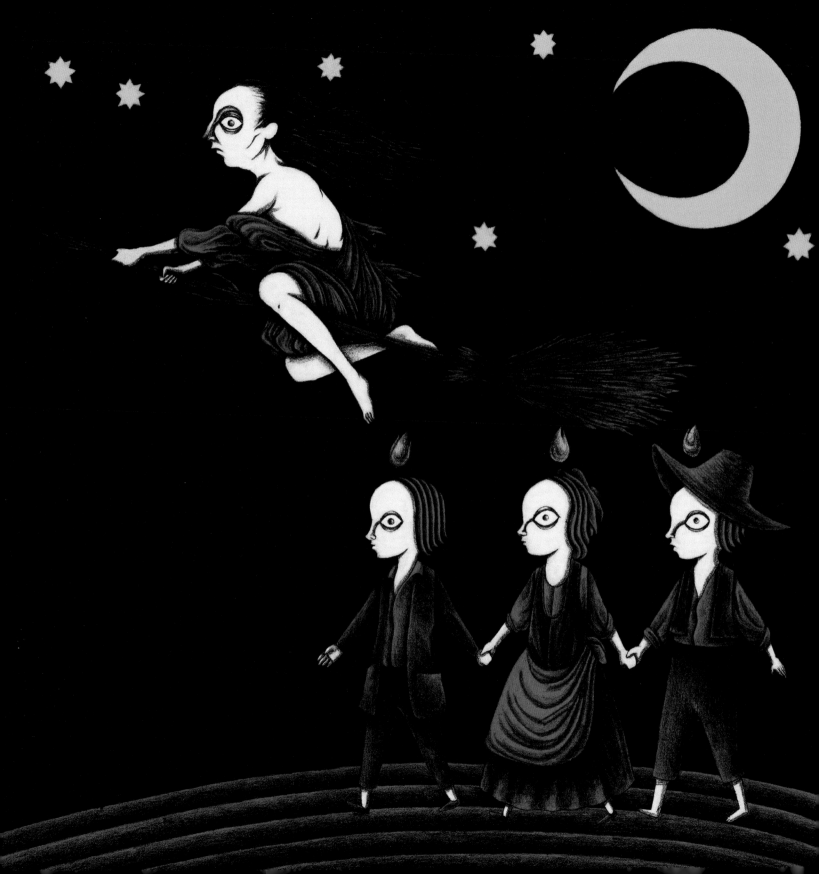

Empusa

Empusa is a popular demoness who reigns during harvest time. This destructive figure with one brass foot and one donkey's foot and crowned with an aureole of flame appears in different forms: viper, dog, or woman.

Empusa commands the noontime demons and with them, she races through the streets wearing mourning garb, terrifying everyone. Peasants who dare to meet her eye will have their arms and legs broken. The only way of summoning this horrible figure is to insult her viciously.

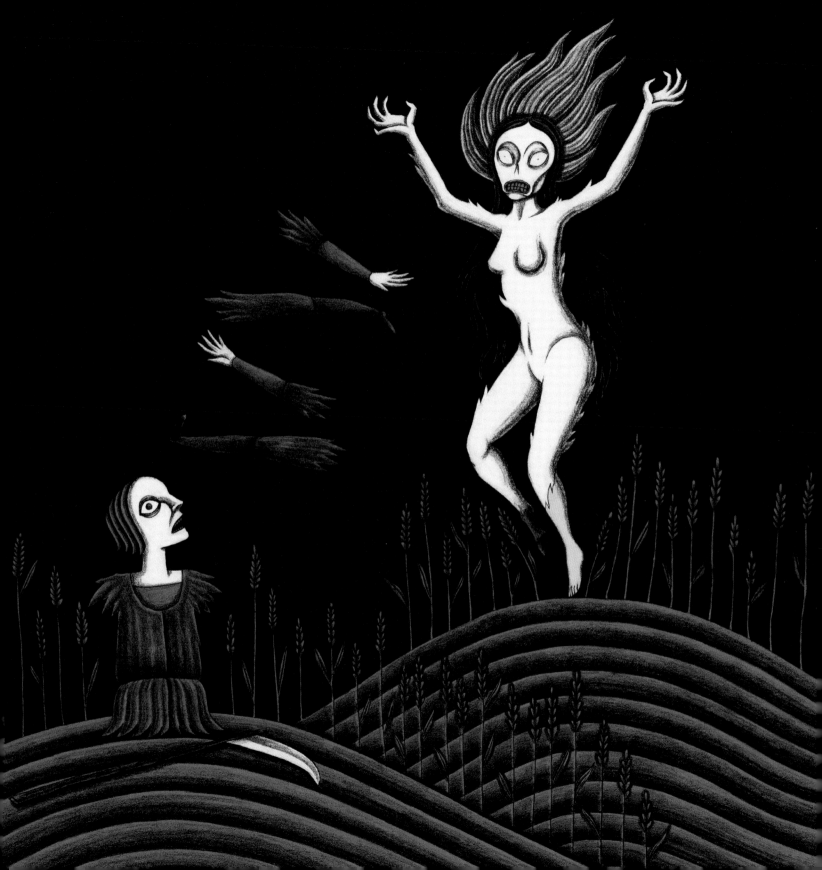

Erlik-Khan

Erlik-Khan, an Eastern demon, is a prince in the infernal aristocracy. His form varies; he can choose from one of the two male heads at his disposal or the head of a buffalo.
He has four legs and carries a scepter topped with a skull in one hand and a sword in the other.
He also wears a necklace made from human skulls, which makes his aggressive and warlike temperament very clear.

44

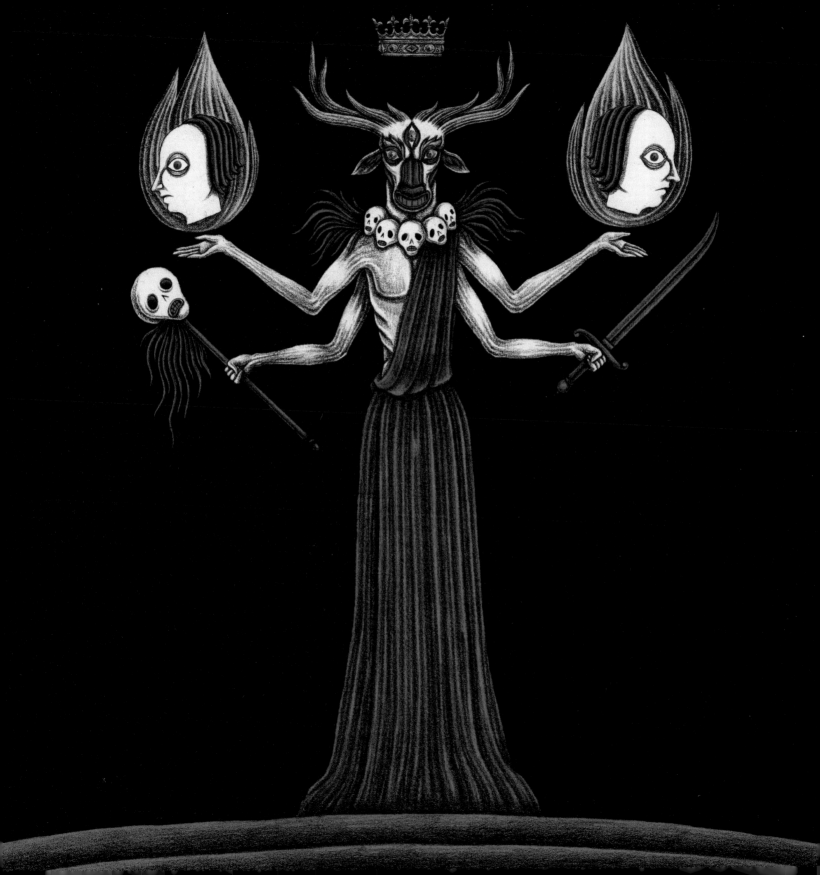

Eurynomos

Crowned by Satan as the sacred prince of death, Eurynomos is a scavenger with long claws and large, razor-sharp teeth. He is feared as much in the underworld as he is above ground.

This very old demon is often shown wearing a fox skin and his body is covered with weeping, rotting wounds. At night he can take control of his victims and kill them.

There is a legend that a statue of Eurynomos decorated the temple of Delphi (4th century BCE) and there he was shown as a dirty, famished wolf seated upon a vulture's carcass.

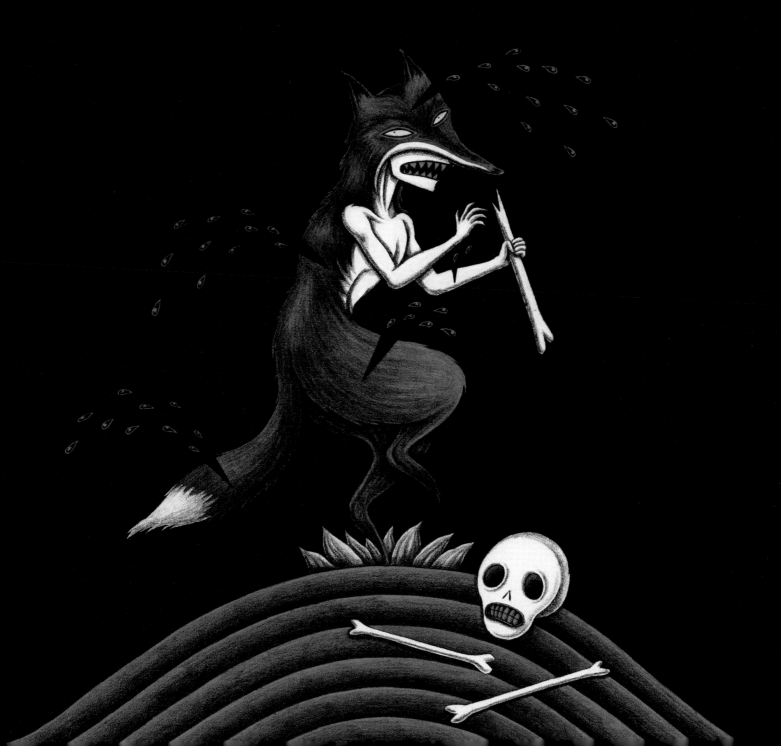

Flauros

Flauros is a powerful and monstrous leopard. His animal form mostly symbolizes his speed,
cruelty, and greed. His eyes are filled with flames when he takes human form. Satan declared him
a general in Hell's army. He raises legions of demons and spirits to find and kill exorcists of all
kinds, his sworn enemies.
He can read the past and the present and he foretells the future.

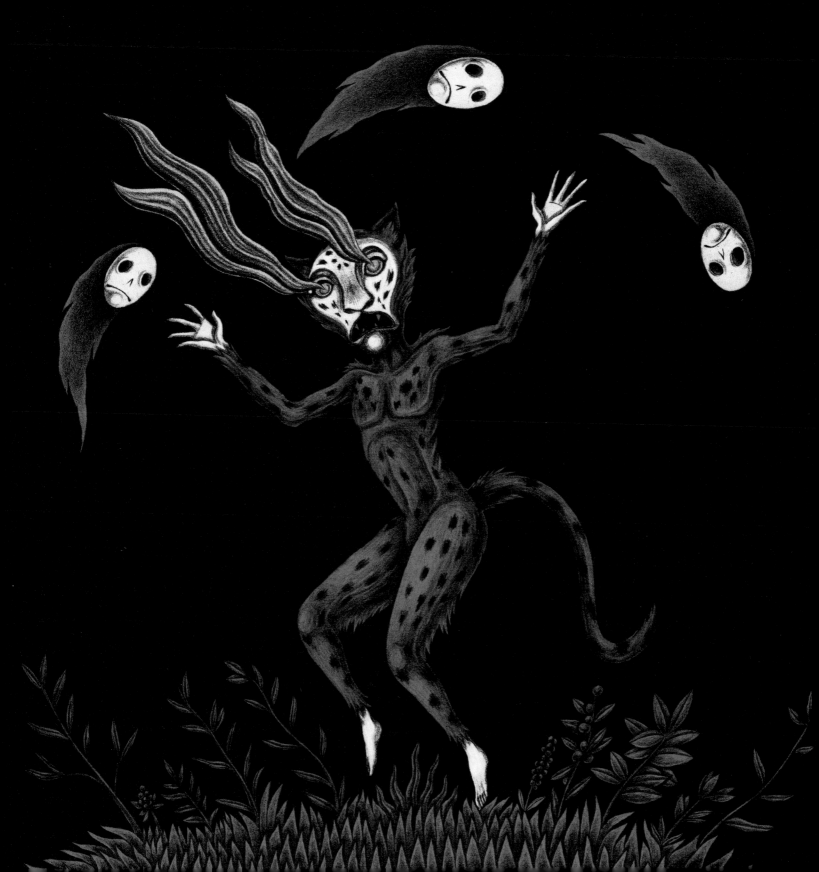

Forcas

A knight with a sharp sword, Forcas is a powerful figure with his beard and long white hair.
Forcas is a high-ranking demon in Hell's army and a celebrated equestrian. He knows the secrets
and virtues of plants and minerals. Wise and generous, he helps those seeking lost treasure and
grants invisibility, eloquence, and cunning to certain men.

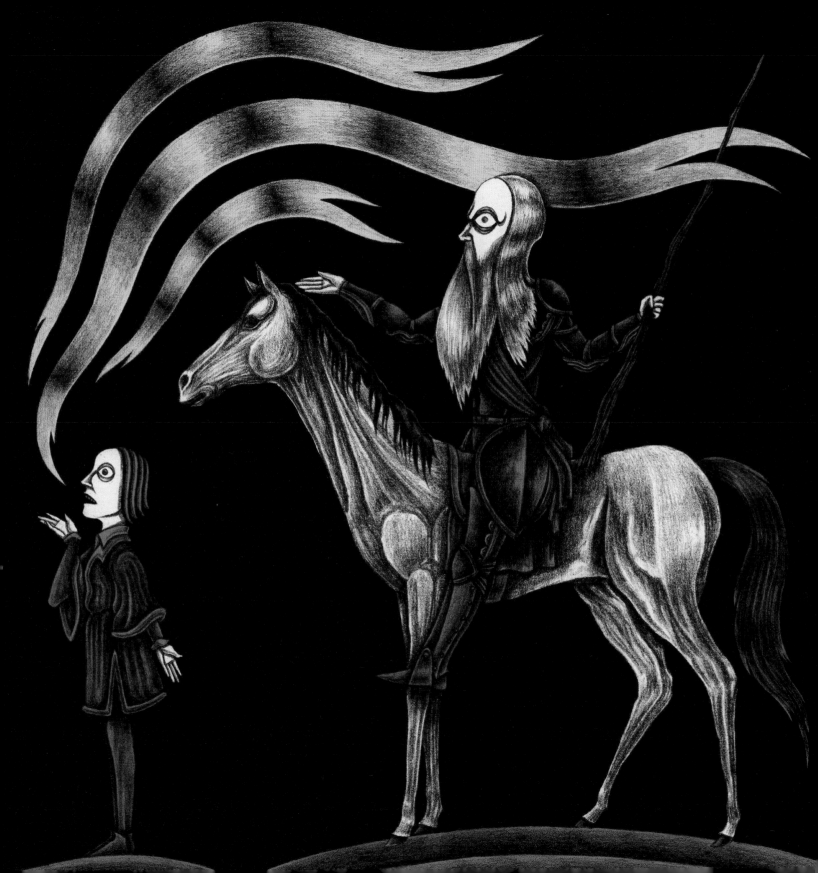

Forneus

Forneus looks like a sea monster. He is a marquis in the infernal aristocracy and commands 29 legions.
Forneus excels in the art of rhetoric and speaks all languages. He can control powerful men and is at ease in the highest spheres of terrestrial authority. He enjoys pushing captive minds toward extremely cruel acts. Despicable Forneus prevents fertility and slows the reproduction of living beings.

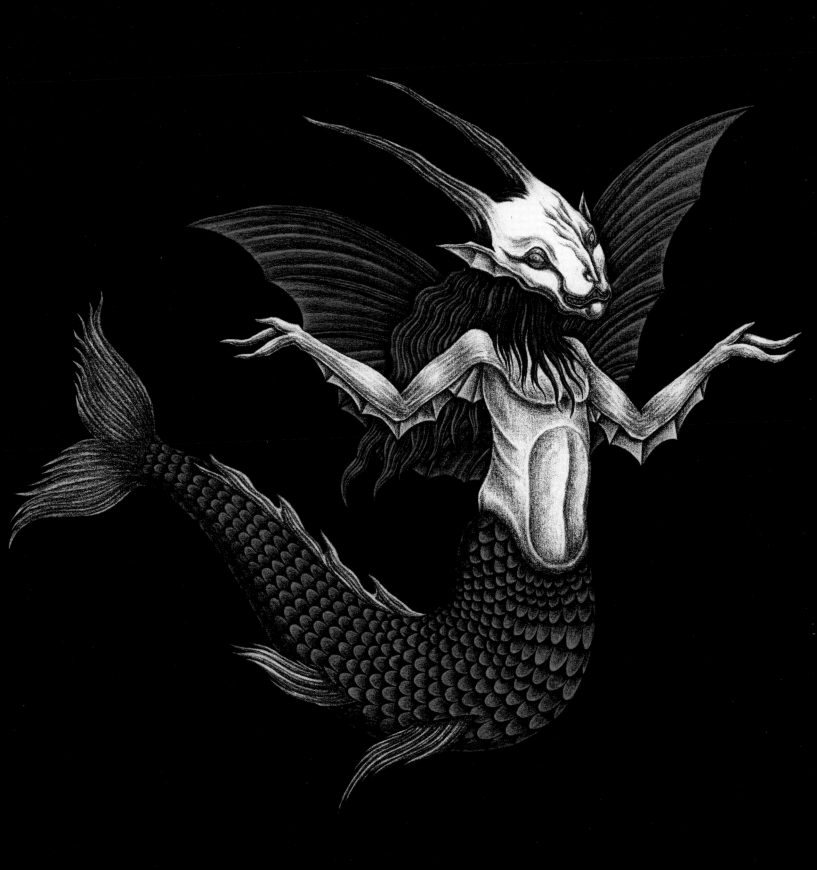

Foxes

The fox has long been considered both very intelligent and extremely crafty. But it is Japan that has granted this animal its most malicious power. According to the Shinto religion, a clever spirit lives inside each fox and is the incarnation of evil. Those who believe this credit the fox with much destruction all over the country.

Furfur

A deer with a tail of flames, Furfur is a lying demon with a raspy voice who can take on an angelic form and manipulate relations between husbands and wives. Furfur is a great and powerful count of the underworld.

He commands lightning, thunder, and storms but his actions and words can be controlled if he is contained within a triangle.

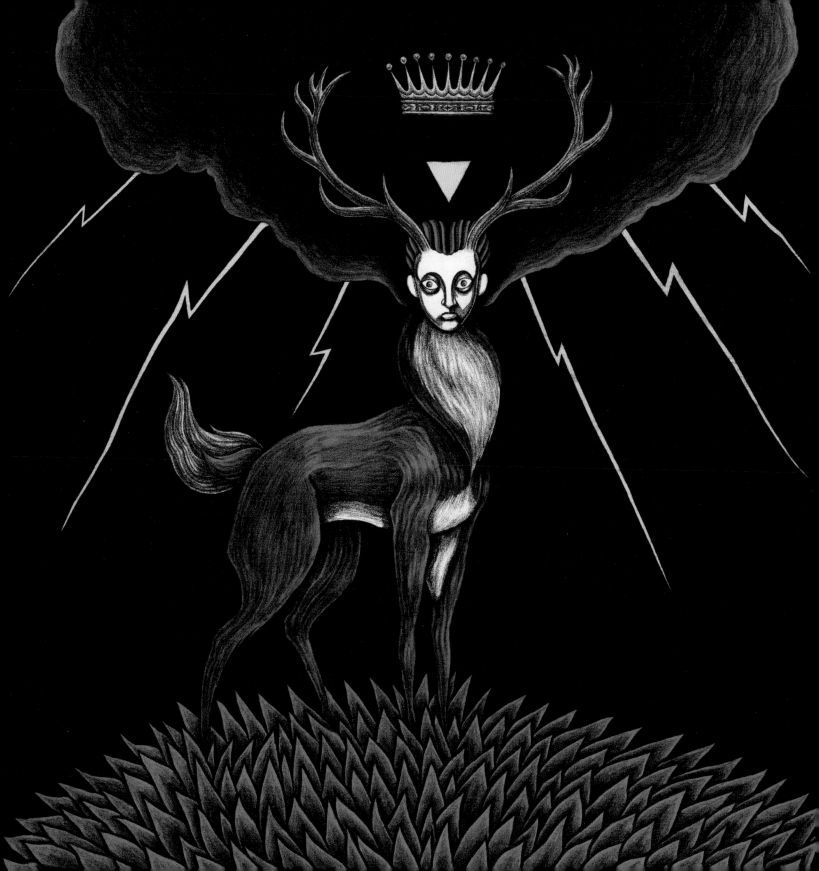

Gamigin

A grand marquis in Hell's aristocracy, Gamigin is depicted as a little horse or a donkey. When called upon by exorcists, he will make a gift of the souls lost at sea as well as those who are stuck in purgatory. He likes numbers and is a willing meddler in financial affairs.

He also teaches the arts and sciences to those who summon him, and he encourages inventions that will be dangerous for the world.

Gantiere

Gantiere was a witch condemned to death in Paris after participating in a sabbath with other evil creatures. When the devil appeared before her, dressed in yellow, he marked her and gave her eight cents to pay her taxes but which she subsequently lost.

Garnier, Gilles

Gilles Garnier lived in 17th-century France and was condemned to death in the city of Dôle. He was burned alive and his body's ashes dispersed to the wind. His crime was having killed and then eaten, sometimes with his wife, several young girls and boys. He was known to be a werewolf, but also killed in his human shape.

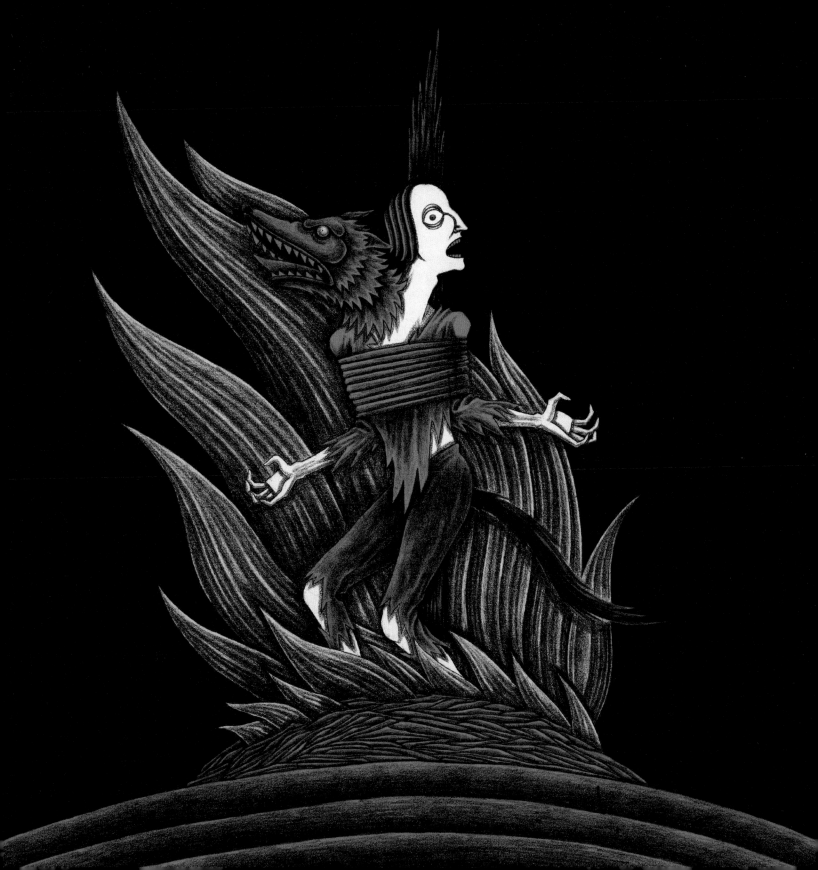

Glasya-Labolas

A rabid dog with the wings of a griffon, Glasya-Labolas is the Lord of Assassins, inspiring murder and festering quarrels. He is credited as the possible inspiration for all murders. *The Grand Grimoire* lists him as a sergeant in Hell's army. He has the power to grant invisibility and can foretell the future.

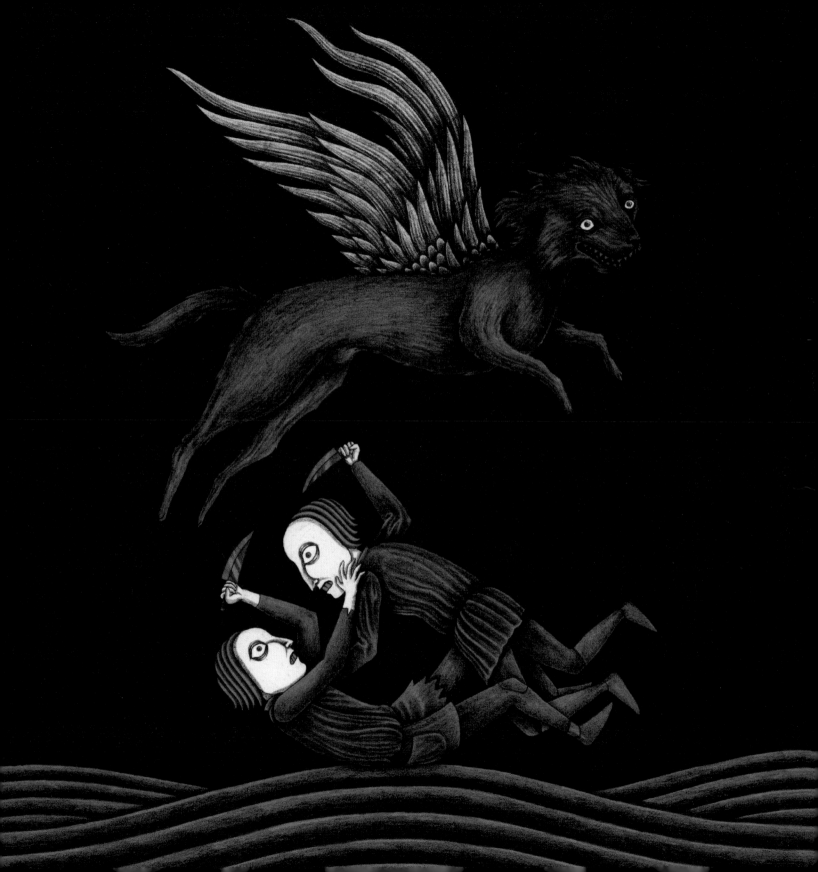

Gontran

Gontran was a soldier for the Archbishop of Reims who is reported to have been taken over by the devil while on watch with a group of other soldiers. While resting beside a stream, Gontran fell asleep with his mouth open. The other soldiers watched a small white weasel exit his mouth and attempt to cross the stream. A different soldier used his sword to make a bridge for the little beast, who crossed and then returned, slipping back inside Gontran's mouth.

When Gontran woke and was questioned, he admitted that he'd dreamt of crossing an iron bridge and that he felt extremely tired and heavy. But he got up and followed the path taken by the weasel (clearly an incarnation of the devil) and unearthed a treasure beside the stream.

Haagenti

Haagenti is depicted as an immense bull with the wings of a griffon. This demon both rules in
Hell and is one of its guardians.

Haagenti symbolizes the connection between the soul and the cosmos that Plato defined as the
feeling that links all humans with the universe.

When Haagenti appears in human form he teaches alchemy, but anyone who summons him will
be rendered sterile, ill, and anxious.

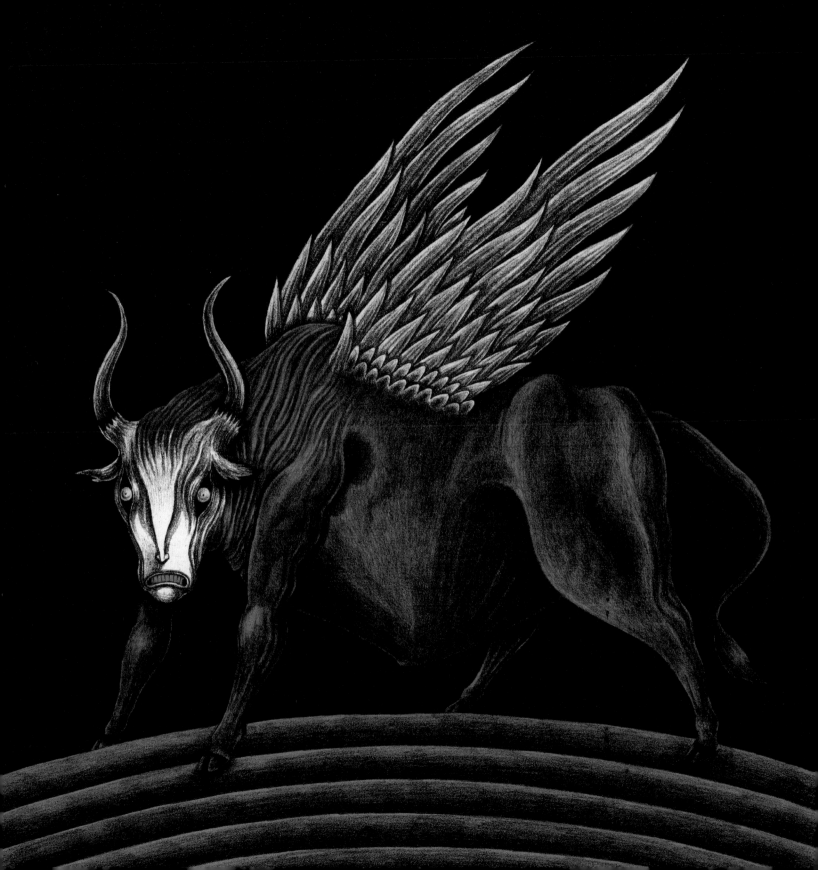

Haborym

The demon of fire, Haborym – sometimes called Aym – rides a viper and carries a torch in his hand, setting fire to entire cities.

In his human form he is charming and a great manipulator, very subtle and malicious. When Haborym takes his demon form he grows two more heads: one of a cat, symbolizing death and evil hexes, and one of a viper, a symbol of illness.

Haborym is a duke in the infernal aristocracy and is always ready to join violent battles and foster death and illness wherever he goes.

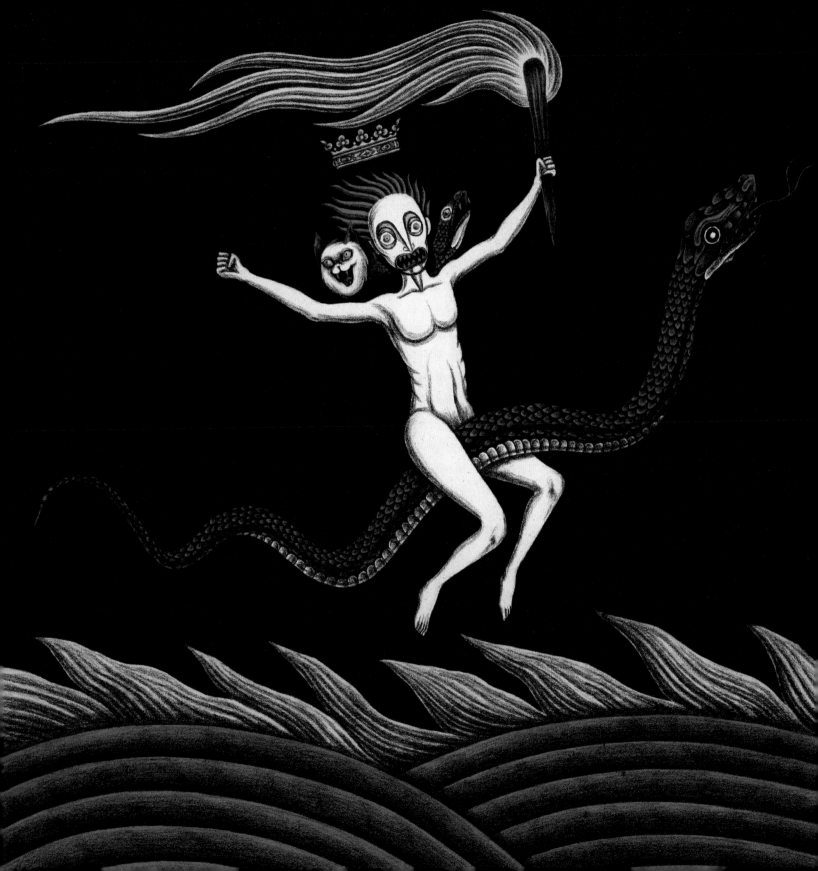

Halphas

Halphas is a powerful count of the underworld with a thunderous voice. He launches wars and then watches from the sky in the shape of a swan. In this seemingly inoffensive state, he gathers non-believers around his cause.
Halphas can turn himself into a mason to construct observation towers or ramparts to defend a city. He is sometimes taken for Malphas, another builder demon, but Halphas is different because he also provides his fighters with weapons and munitions for their wars.

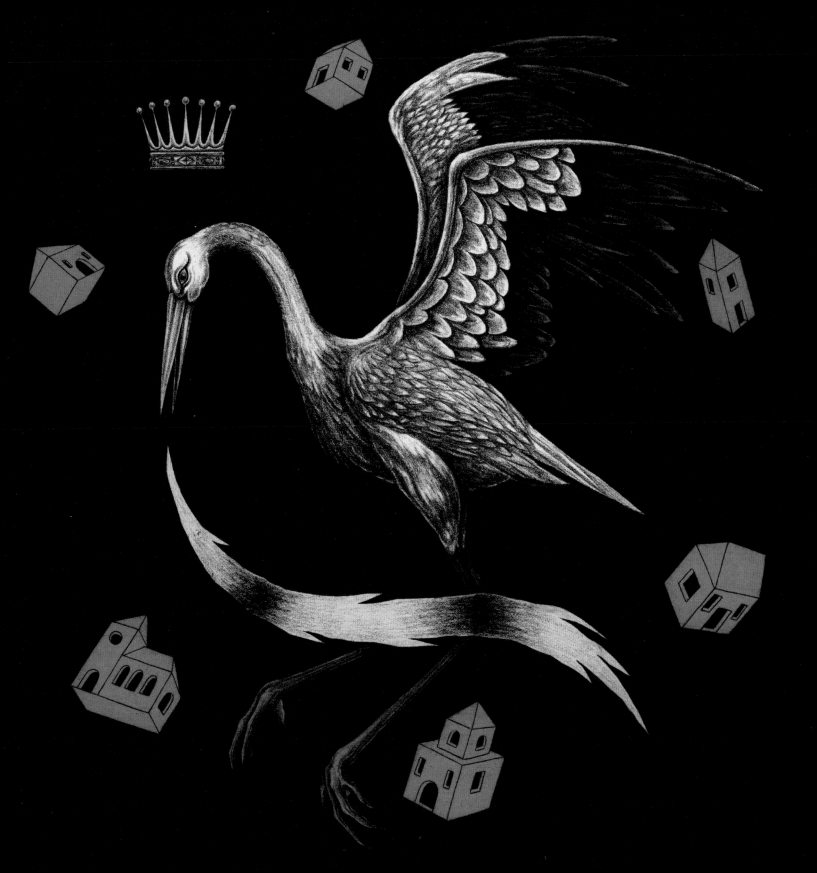

Hecate

Hecate belongs to Greek mythology. She is one of the goddesses of the moon; she is either the new moon or the black moon.

Hecate has two opposing qualities: she is a fertility goddess of the Earth, helping lost souls find their way, but she is also a goddess of shadow and death. She has three faces: a dog, a horse, and a woman. She can make dogs bark as she wishes, make the earth shake, and unleash storms.

Hecate is the goddess of crossroads and helps connect the Earth, Hell, and the Heavens. She masters witchcraft and can visit Hell alongside its most powerful demons.

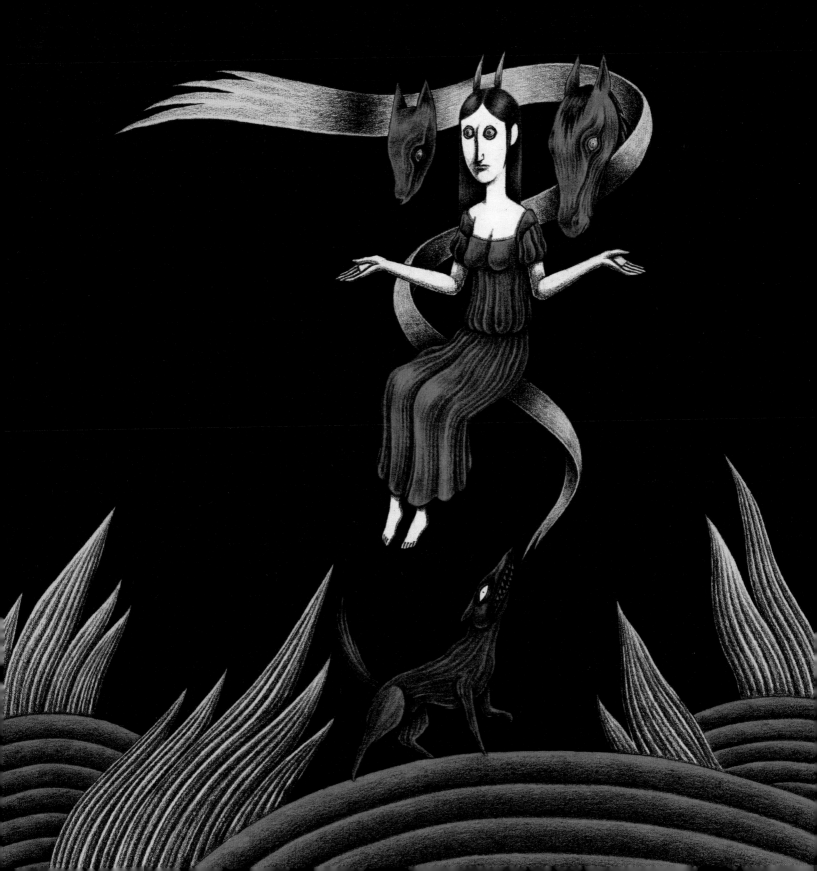

Incubus

The incubi are male demons who abuse women while they sleep. They are very hairy and often depicted with goat's feet, which means they are sometimes, although wrongly, associated with the god Pan. These lecherous creatures can smother their victims in order to possess them. The succubi are their feminine equivalent.

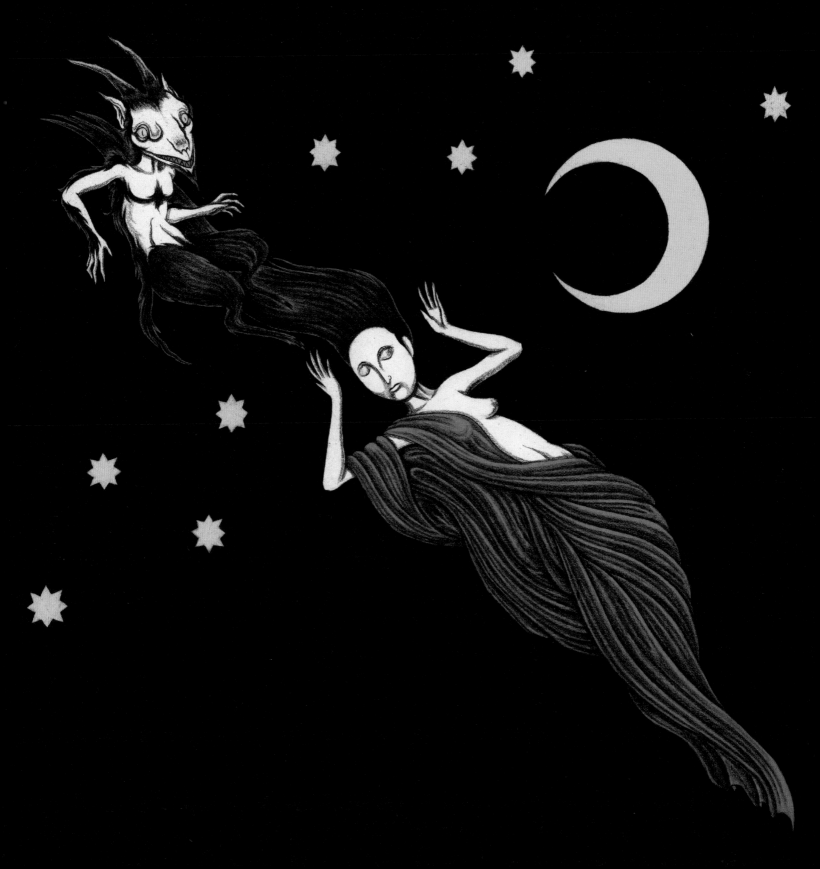

Ipos

A very special-looking beast with the head and feet of a goose, the tail of a hare, and the body of a lion. This demonic prince is often summoned by mortals because he has the power to make stupid people intelligent, boring people interesting, and shy people confident. He is able to make humans trust him because he appears in the form of an angel with a halo.

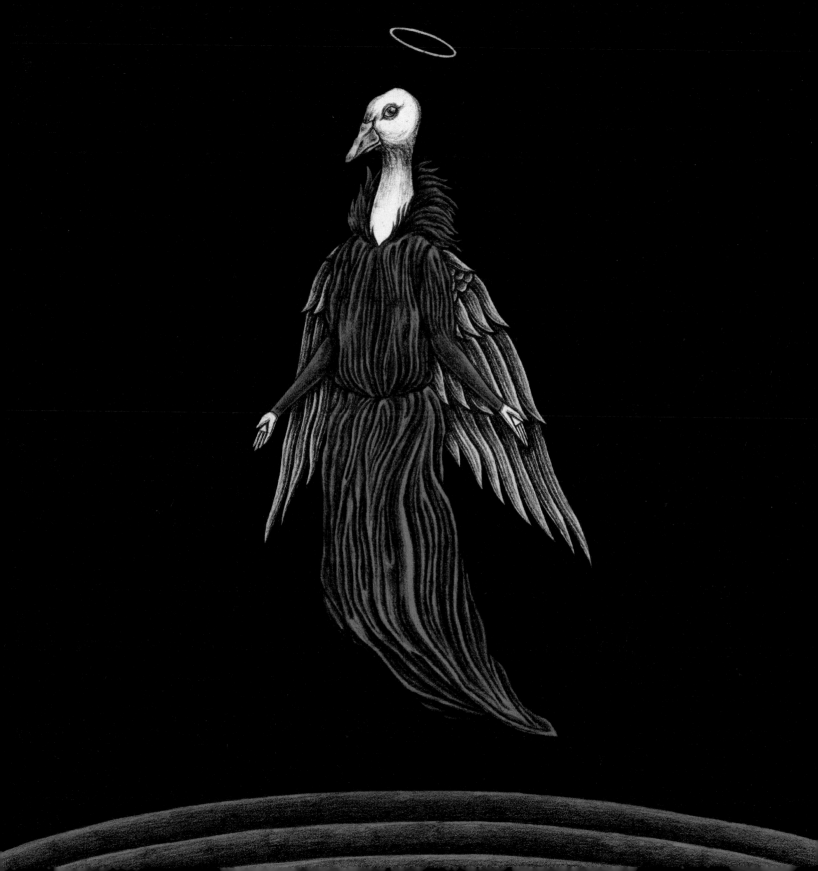

Iwangis

The Iwangis are sorcerers living in Indonesia's Maluka Islands. They are poisoners but also love
to eat fresh cadavers. To protect their deceased, the Malukans keep watch over their graves until a
cadaver is completely decomposed.

80

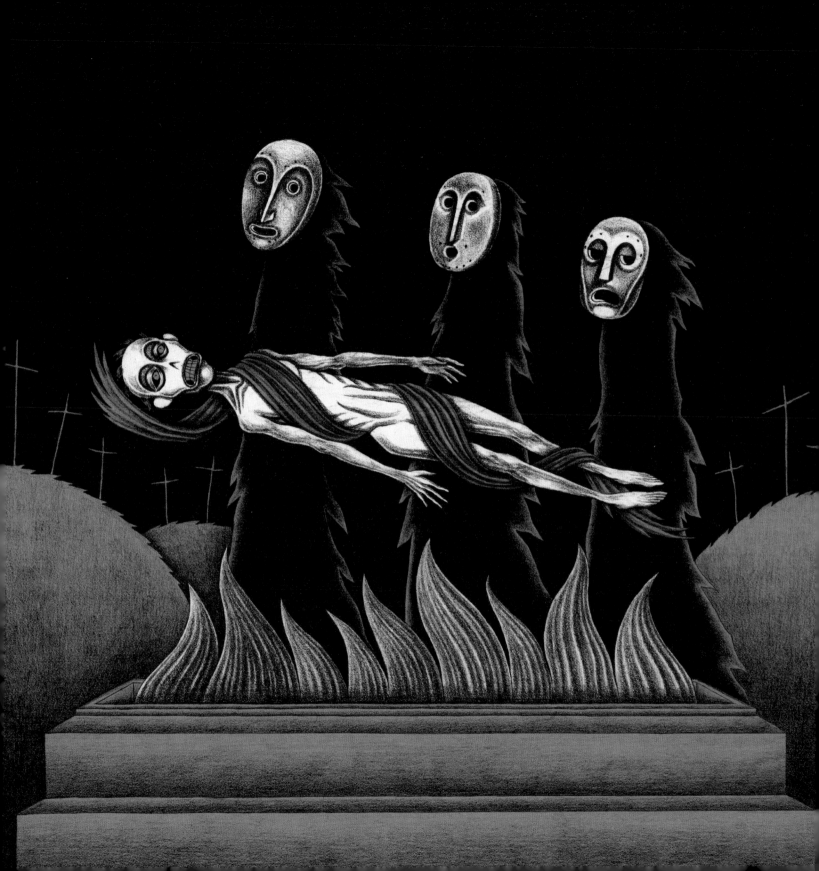

Jack

The eerie flickering light often seen in marshes or bogs was called the will-o'-the-wisp or "Jack with the lantern" and its personification, Jack, belongs to the category of fire demons. John Milton called him the monk of the marshlands. Jack dances in swampy meadows, leading those who follow him to a certain death: by falling off a cliff or even through spontaneous combustion (caused by the alcohol he offers).

The English expression "Jack-o-lantern" appears around 1660. This character is mostly associated with Halloween and originates in an old Irish folktale in which Jack is a drunken, greedy, and selfish blacksmith.

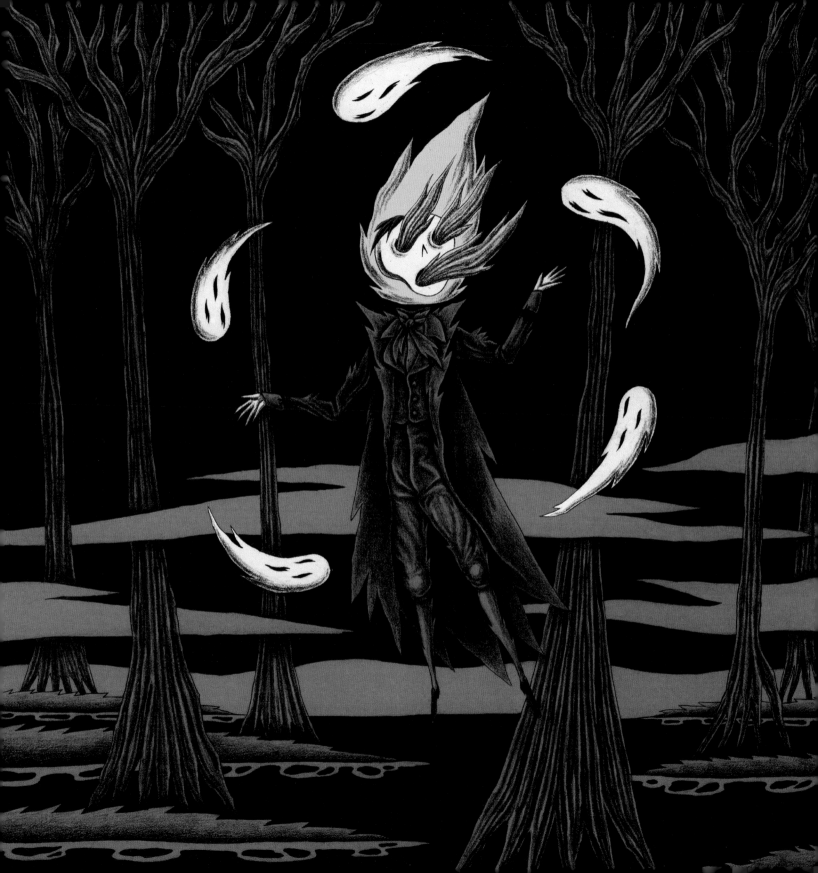

Jezebel

The Queen of Samaria, an ancient kingdom in Israel, Jezebel was accused of leading the Jewish people astray. She introduced the cult of Baal and Asherah to her kingdom. These were fertility deities, but her crime was more about turning her people away from God at a time when the monotheistic religions were growing in power.

Jezebel convinced her husband to persecute her people, especially the prophet Elijah. Because of this and because of her demon idolizing, Jezebel was thrown from a high tower and then given to a pack of dogs to eat.

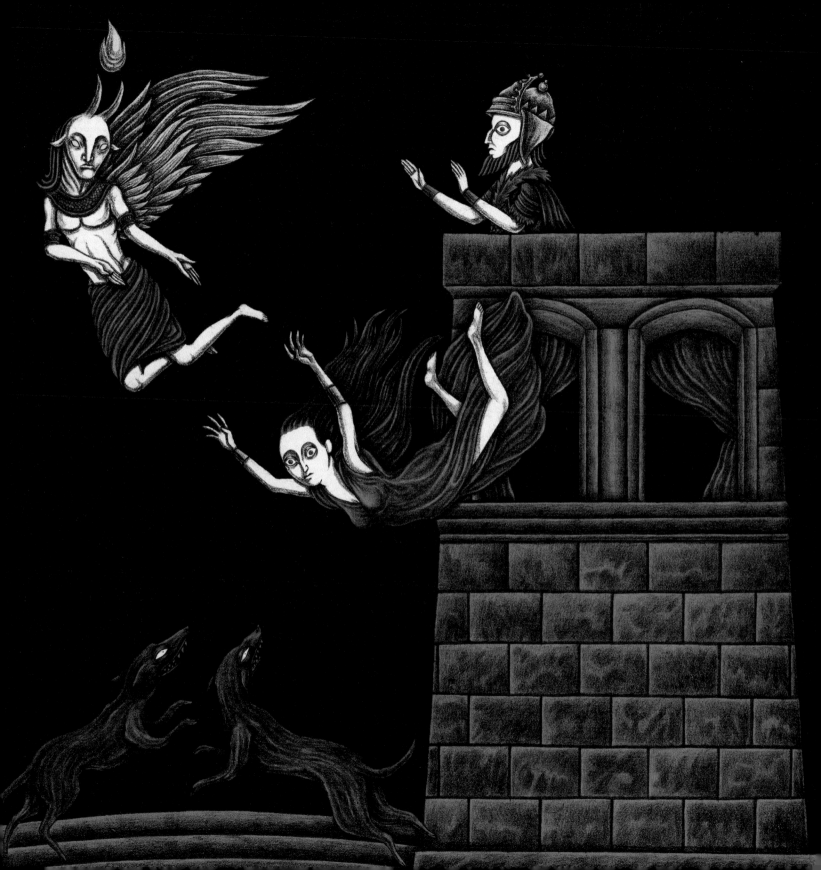

Kantius of Silesia

It is said that Kantius, an alderman living in the 18th century who was crushed to death by his horse, would leave his tomb and torment the inhabitants of his village. A belief in vampires was widespread at this time and it was decided to "kill" Kantius's corpse as if it was a vampire. He was exhumed at great difficulty, using the horse that killed him. He was attached to a post during the daylight hours when vampires should be sleeping, but the corpse would not burn. He had to be cut up and burned to ashes before the demon was finally laid to rest.

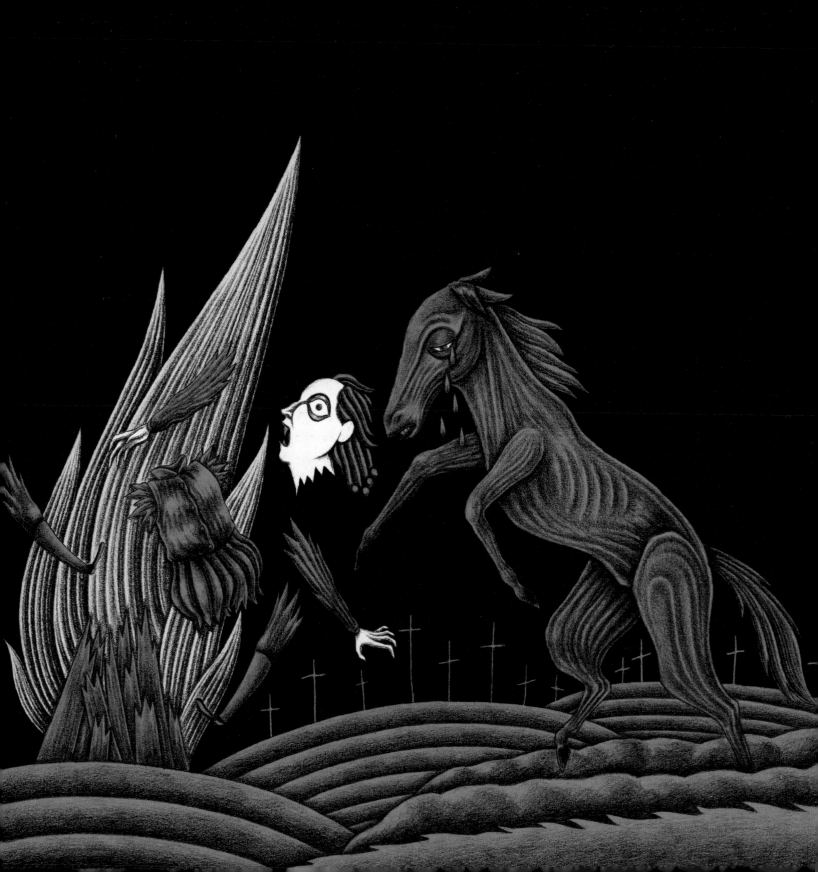

Kerikoff

Kerikoff, particularly well-known in Russia, is a lake demon with the feet of a horse and gigantic black hands. He creates terrible waves and overturns boats. Any survivors who attempt to hold fast to the broken pieces of their boats or a barrel are hounded by the horrible spirit who hovers over them, watching from above with his monstrous human head.

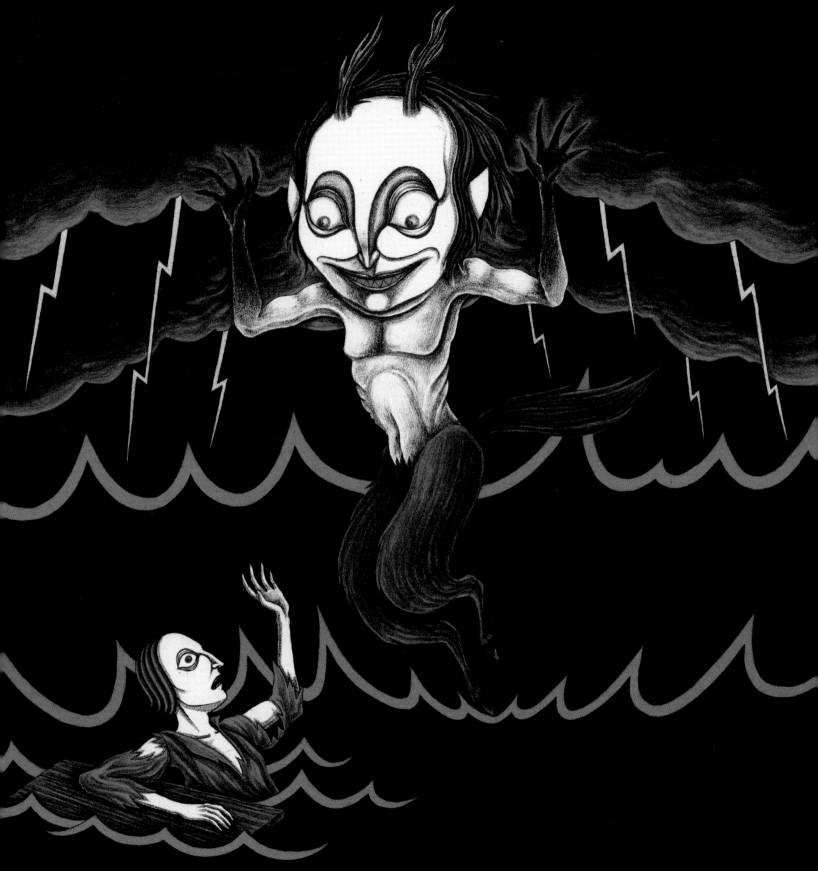

Kisilova, The Vampire of

Kisilova is the name of a Balkan village where an old man died and was reincarnated several days later as a vampire. His son reported that his dead father visited him in the night and asked for food. After several days, the son died without any obvious cause. Other villagers died in suspicious circumstances and the village authorities exhumed the body of the old man. They discovered a cold, dead body that was breathing normally and whose eyes were vermillion-colored and wide open. The town executioner drove a stake into the heart of the cadaver and the corpse was burned to ashes.

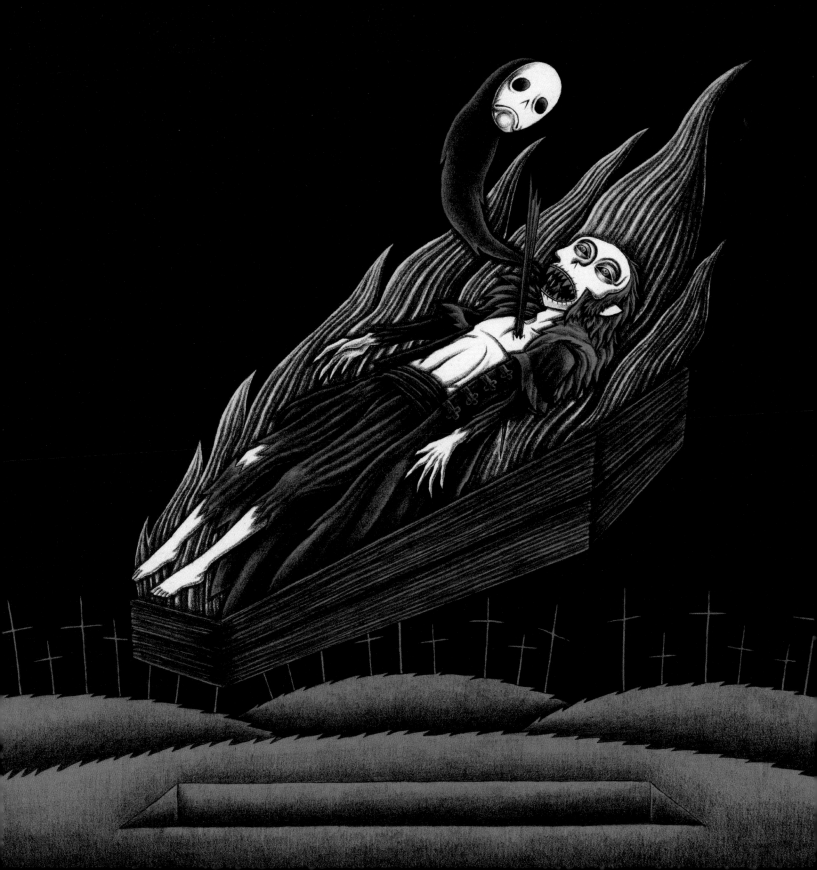

Kraken

A tentacled marine monster with shiny horns, the kraken is most often spotted off the coast of Norway. Because of its gigantic size, even the slightest movement of its body will capsize the sturdiest boats. If it doesn't move, however, fisherman can take advantage of its nearness to find an abundance of fish. The fish are attracted by the smell of the monster's excrements and rise to the surface in great numbers.

The kraken rarely moves, which is why its head is covered in plants and trees of all kinds, which confuses anyone who sees it because they believe it is an island.

The cadaver of the kraken has never been found because the monster will never die; no weapon will ever be strong enough to put such a creature to death.

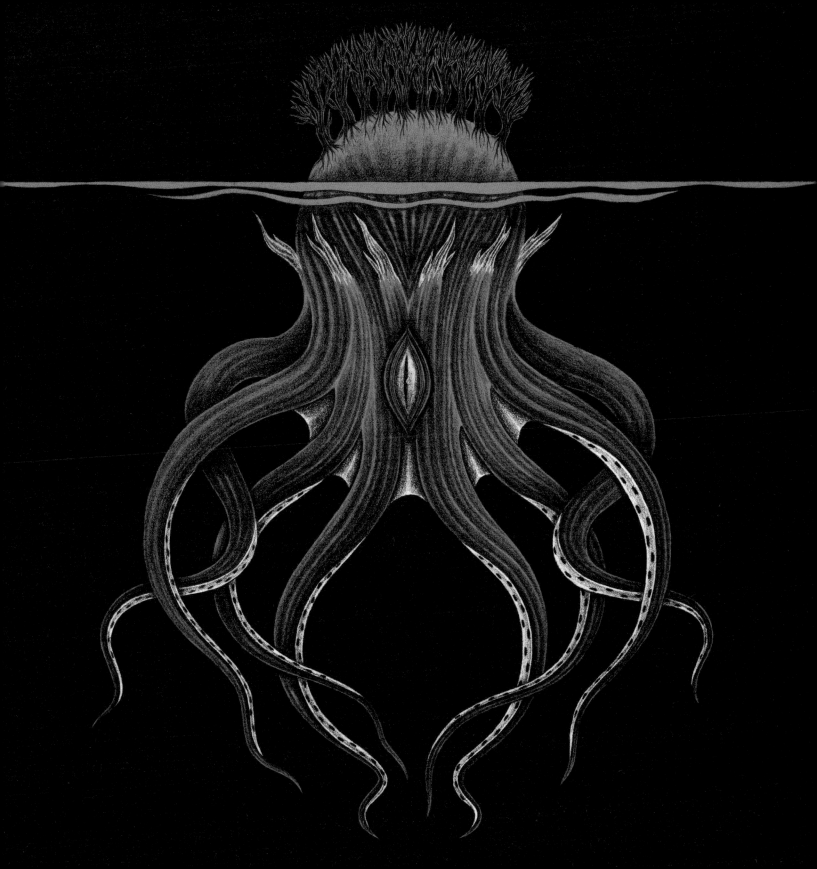

Leshy

Leshiye are Russian satyrs. Most often they resemble goats: horns, hooves, tail, and beard. But leshiye can also take the shape of any animal or plant. Their skin and blood are blue and their hair is made of foam. Leshiye command the obedience of all animals and if one wants to attract their favor, one must leave an offering on a stump: an egg, a piece of bread...

In the grasslands, these forest beings are small, but they become huge when surrounded by trees. Their shouts are frightening. They sometimes steal young children or young women walking near the forest. Leshiye guide their hapless victims to caves and tickle them to death.

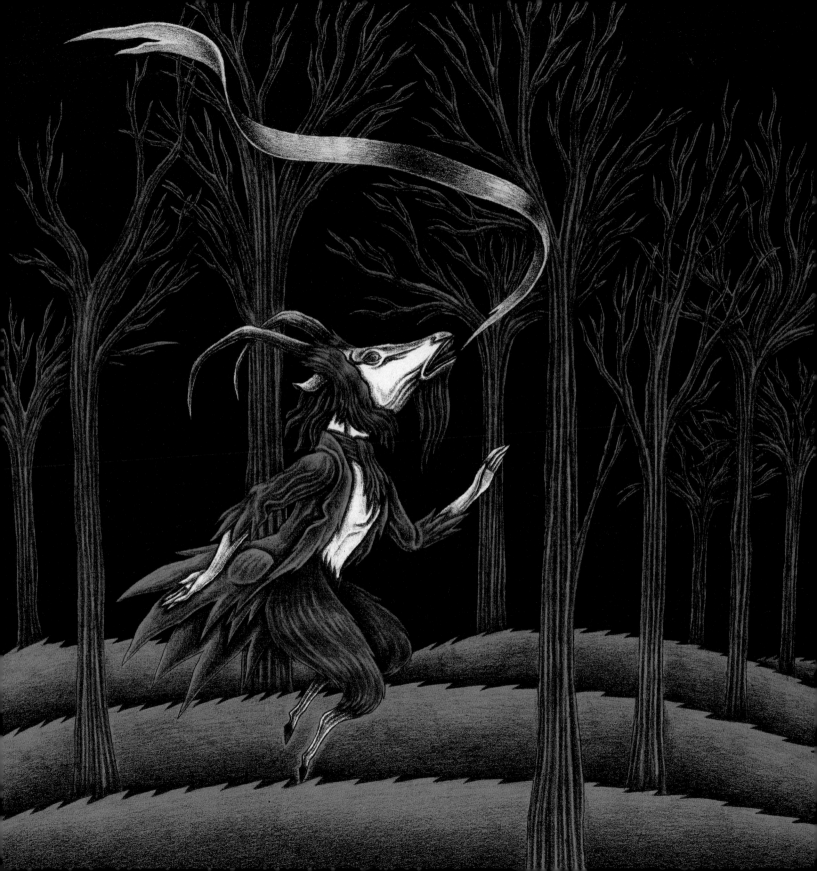

Leonard

Leonard is the grand master of the sabbath, and often presides in the shape of a large goat
with wide fiery eyes and the ears of a fox. He has three horns, hair that sticks up, and a face on
his rear-end that his followers will kiss while holding a green candle.
He is overlord of the junior demons and is often called The Black Man. He is melancholy and
displays a magnificent gravitas.

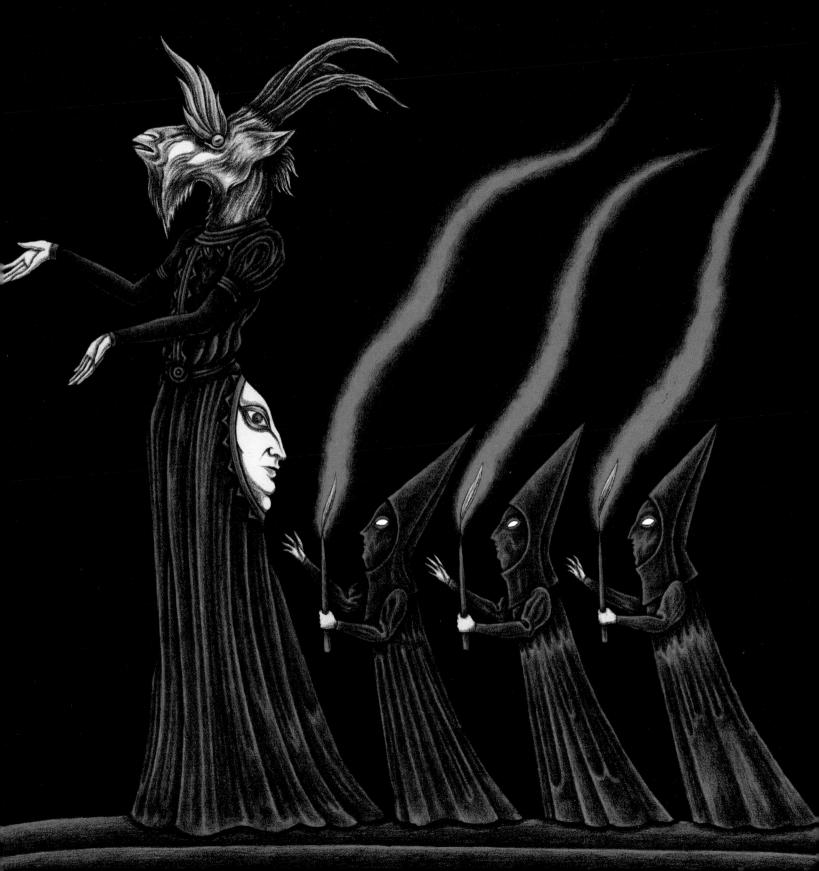

Leviathan

In Hebrew, "leviathan" means monster of the waters. God created a pair of fish named leviathans.
They were so strong that God finally killed the female to keep them from overturning and overtaking
the world. He salted the sacrificed fish for the Messiah's meal.
It is also said that this giant fish swallows other fish in one gulp and that he is so monstrous that he
carries alone the entire mass of all the waters of the world.
The Leviathan, an admiral in Hell's army, is also called the "great liar" because he teaches humans to
lie and manipulate. He is stubborn and difficult to exorcize.

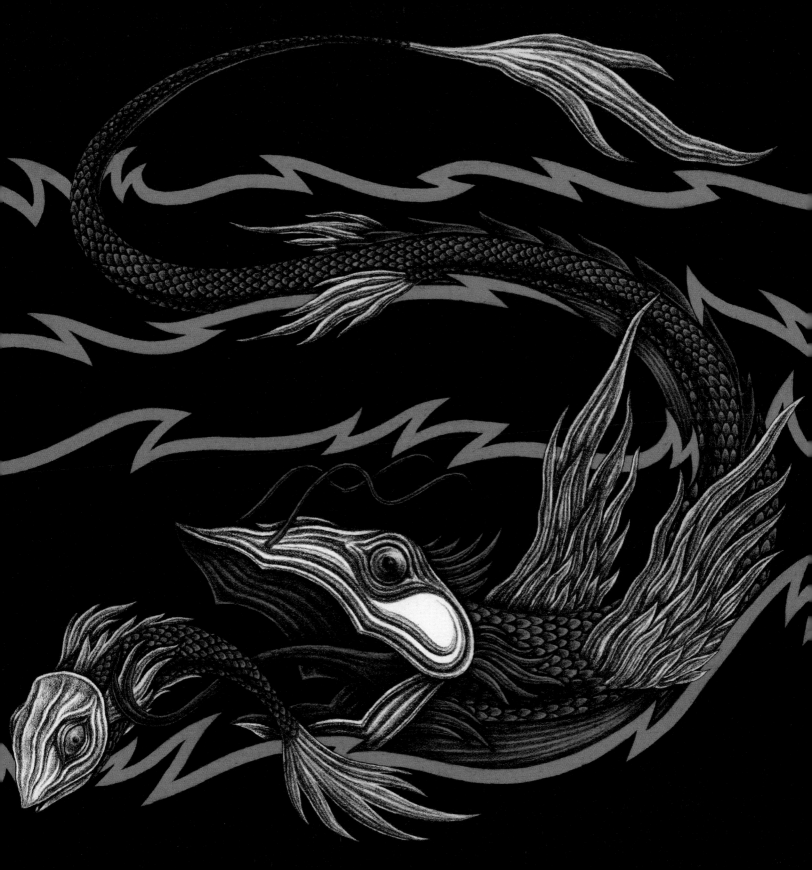

Lucifer

For some, Lucifer is superior to Satan. He is certainly the greatest and strongest of the demons.
He is often described as the king of the underworld. His name means "bearer of light."
Lucifer is associated with pride. Originally an angel who wanted to overthrow God, he brought
other angels down with him in his fall.
He likes to heckle witches by stealing their broomsticks and there is nothing monstrous about
him even if his face becomes enflamed when he's angry, his eyes are filled with hate, and there
are two horns on his forehead.

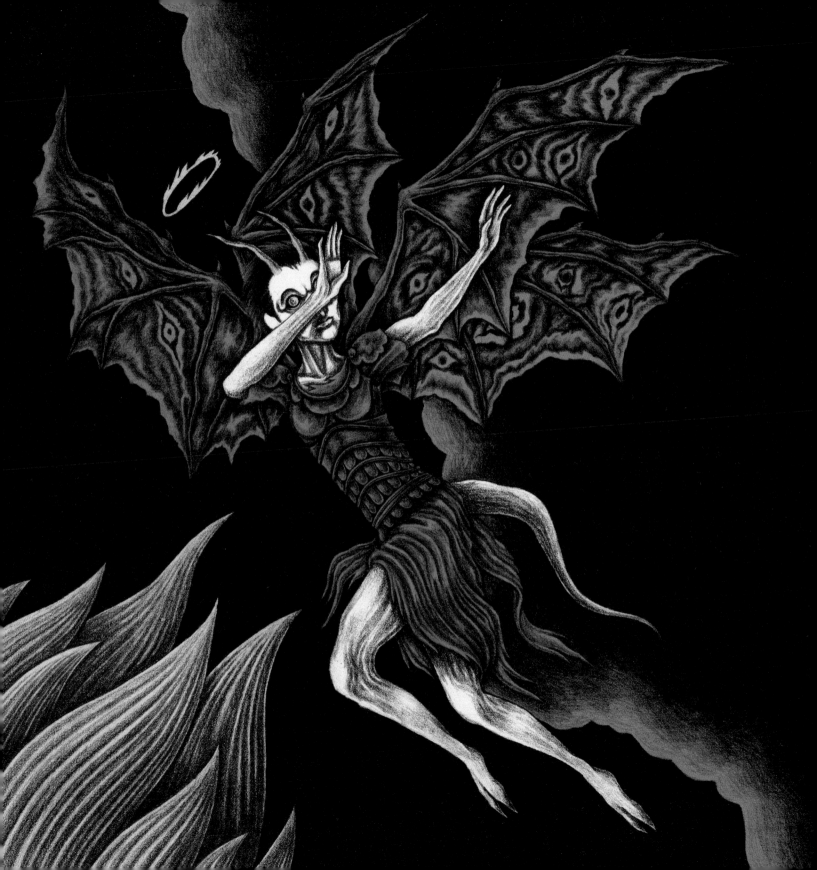

Malphas

Malphas can appear as a human but prefers to take the form of a raven. His voice is raspy and he is an immensely cruel demon with a high rank in Hell's aristocracy.
In his raven form, Malphas can discreetly spy on enemy cities and discover their wartime strategies. Indeed, Malphas constructs invincible towers and citadels, defending the cities he builds. But he can also destroy what he wishes with the same skill.

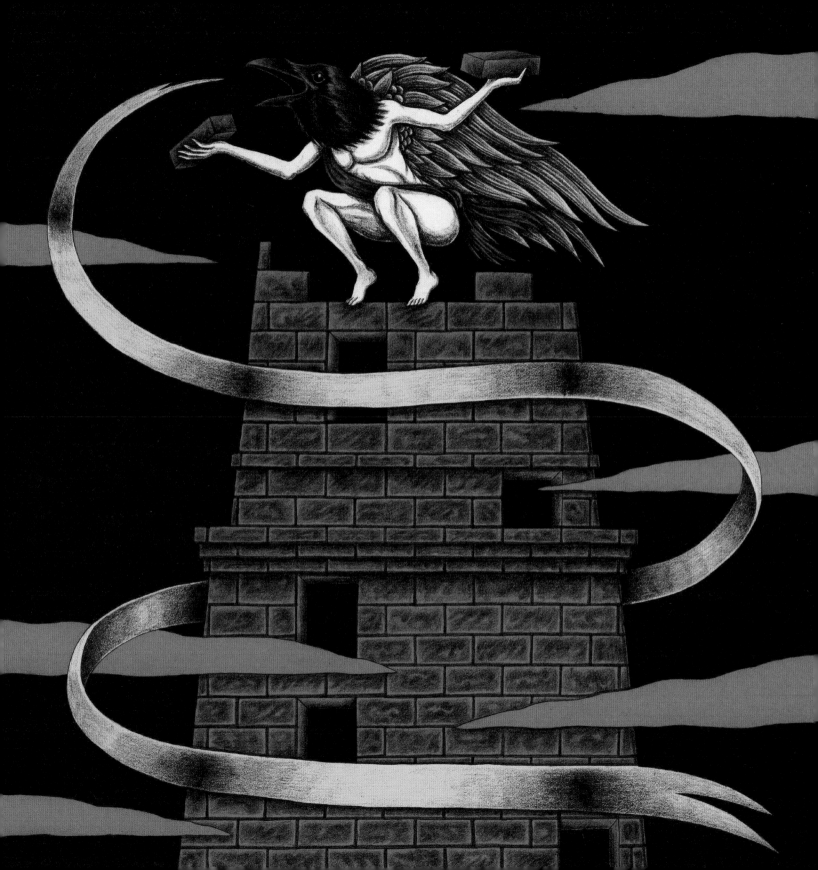

Marchosias

Marchosias is a fallen angel who appears in the form of an elegant fire-spewing female wolf with griffon wings and the tail of a serpent.

Those who are skittish will be immediately frightened away, but anyone brave enough to draw near will receive the wisdom of this demon. Marchosias is unrivalled at resolving conflicts, whether physical or verbal.

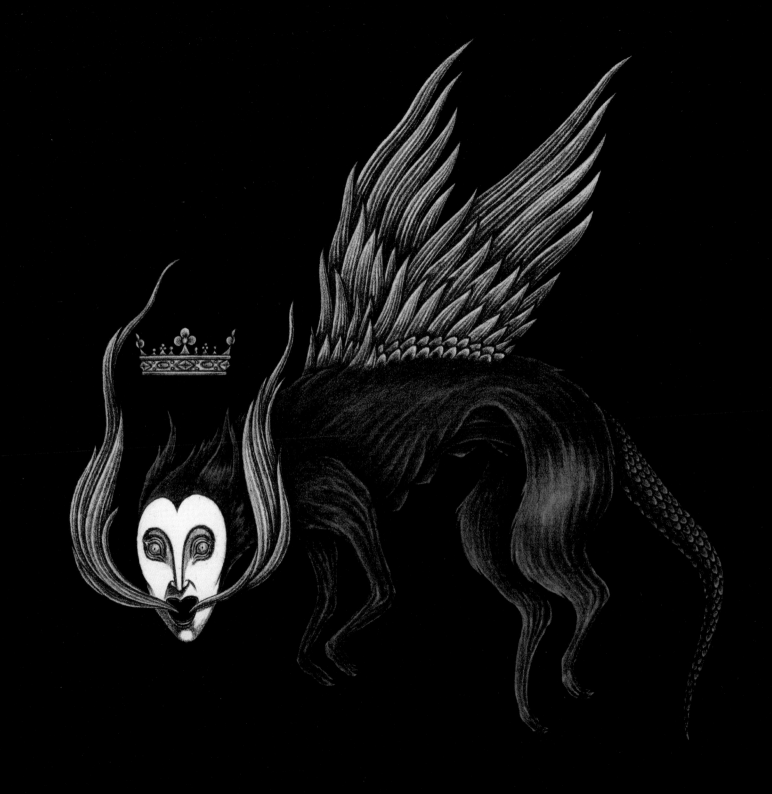

Martibel, Sarena

Sarena Martibel was a 15th-century French witch. It is told she danced at the sabbath with her four clothed toads. Reports claim that one rode on her left shoulder, the other on her right, and the two others sat upon her wrists in much the way a hawk or falcon rest on the arms of the falconer.

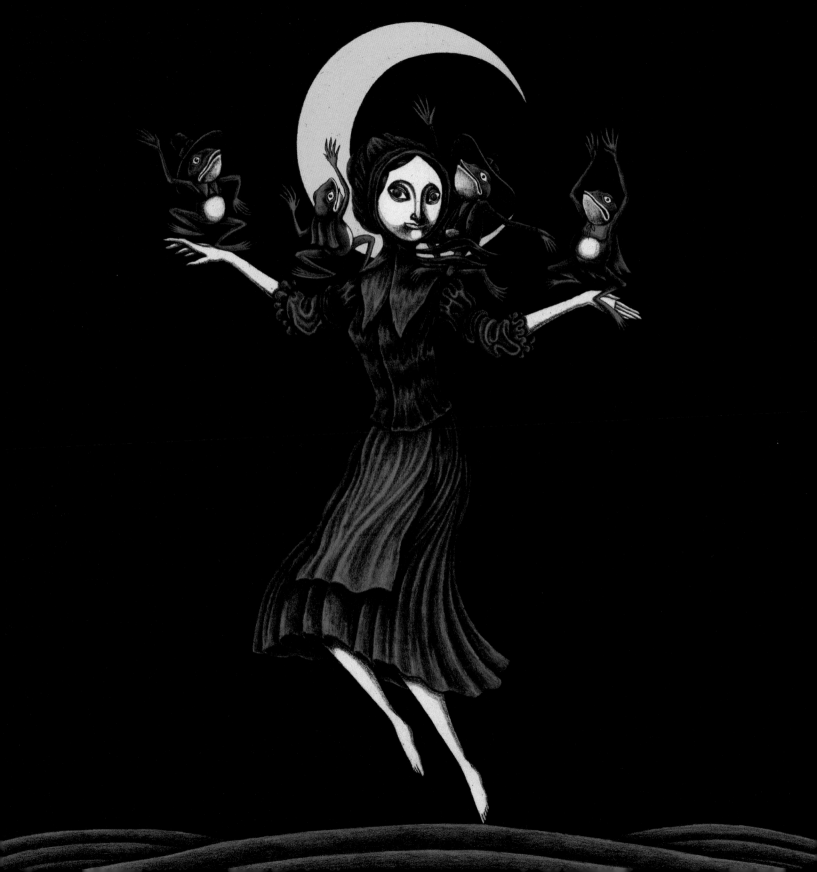

Monsieur de Laforet

A mythical character from the Fontainebleau woods, he is sometimes called the Grand Veneur or the Black Hunter. He appears in English folklore as the headless huntsman.

He rides loudly through the woods, a harbinger of bad luck to anyone who sees him. A child was once found dressed in a wolfskin, claiming he'd seen Monsieur de Laforet. The latter, wanting to approach the child, had to turn back in his tracks because the child made the sign of the cross to protect himself.

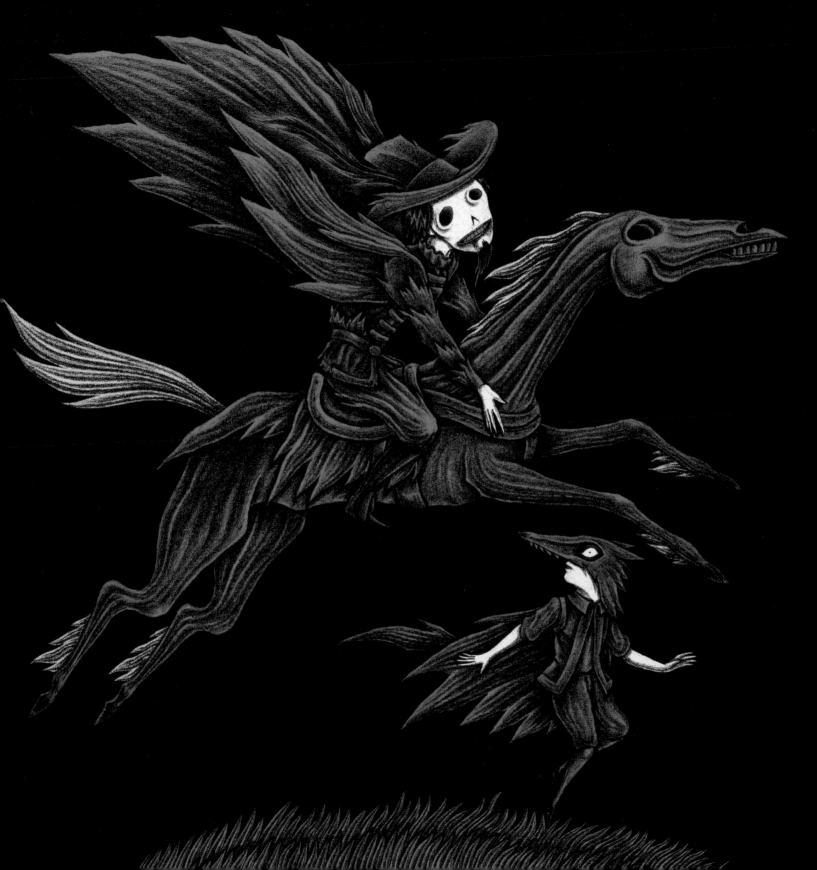

Naberius

A marquis of the underworld, Naberius takes the form of a raven. He is a powerful wizard who can determine the purity of metals, plants, and animals. He is also known to give the Hand of Glory to brigands. The Hand of Glory is a precious charm. Composed of a hanged man's dried hand, the fingers are covered in an oil that makes it possible to light it like a candle, giving light to only whomever owns the hand. Thieves use it to enter darkened homes without being seen. The locks on doors and windows give way when touched with it. There are many legends from different cultures about the Hand of Glory, but all describe that it gives power to whomever possesses it.

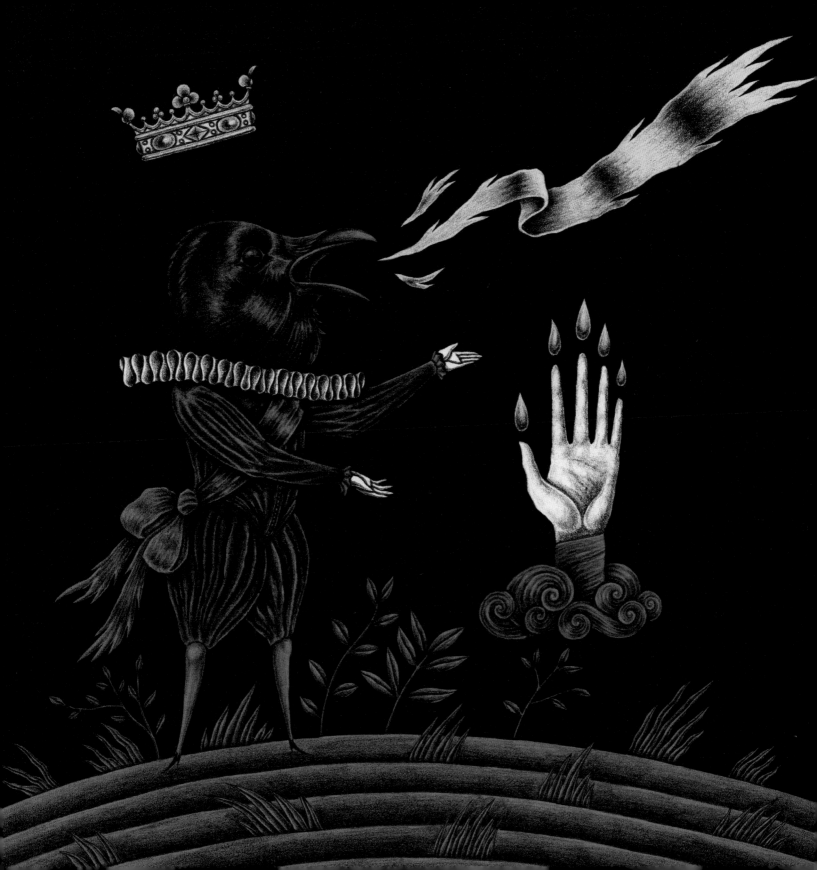

Necato

From the Basque lands, Necato was a hideous, frightening witch. Her chilling cat's eyes, her satyr's beard, and her raspy voice were terrifying for anyone who dared approach her.
Necato was imprisoned and condemned in August 1609 for attending rituals and ceremonies, even when imprisoned. The authorities believed she could send her spirit to attend without her physical body. She was burned in Hendaye for changing her sex and leading women to the sabbath.

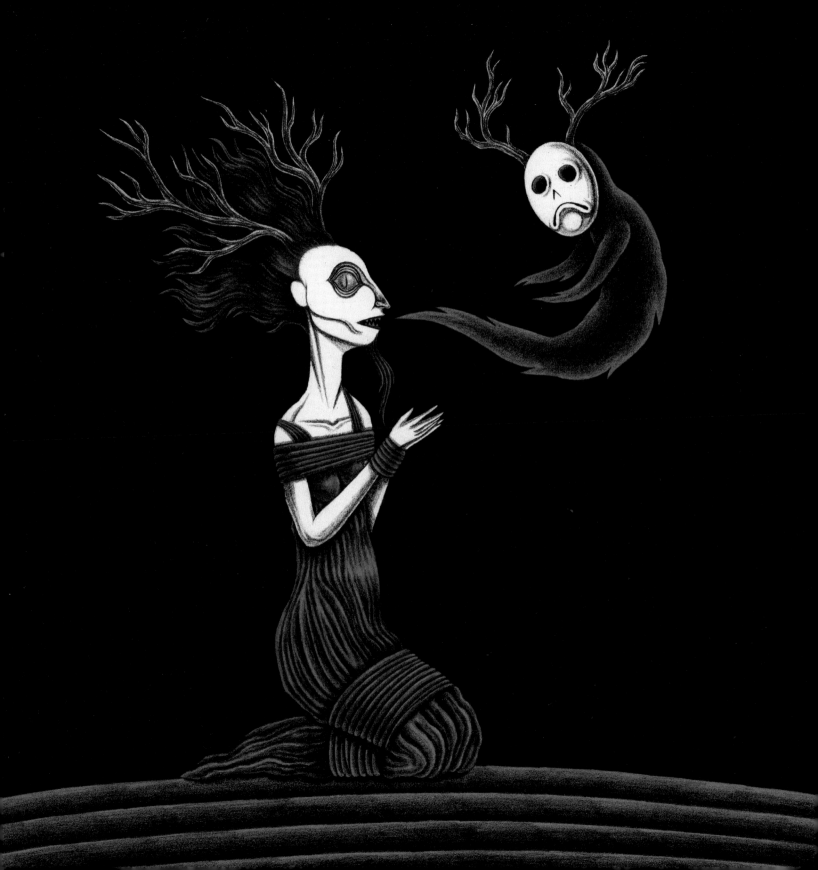

Nybbas

A low-ranking demon who likes to parade around the courtyard of Hell, playing with the visions and dreams of mortals. He is not well-respected and considered a charlatan. His status is represented by his buffoon's attire, complete with bells and a hat.

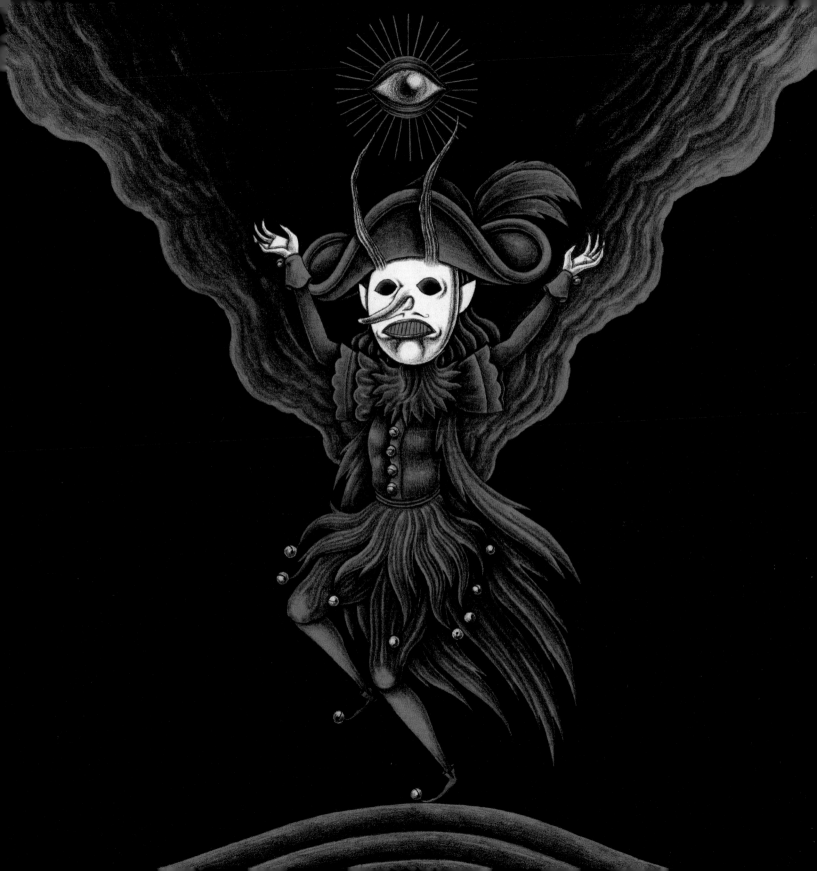

Nyol

Nyol was the 16th-century Viscount of Brosse and considered a sorcerer. He was arrested for participating in the sabbath, poisoning crops and cattle, and spreading disease.
As the story goes, the devil appeared to Nyol as a black goat. To prove his faithfulness, Nyol offered him his belt, a lock of his hair, and one of his thumbs. He also admitted that the devil made him dance at the sabbath with other sorcerers and witches, each individual carrying a candle. When the devil finally went away, everyone was magically transported home.
Nyol was condemned to death for sorcery.

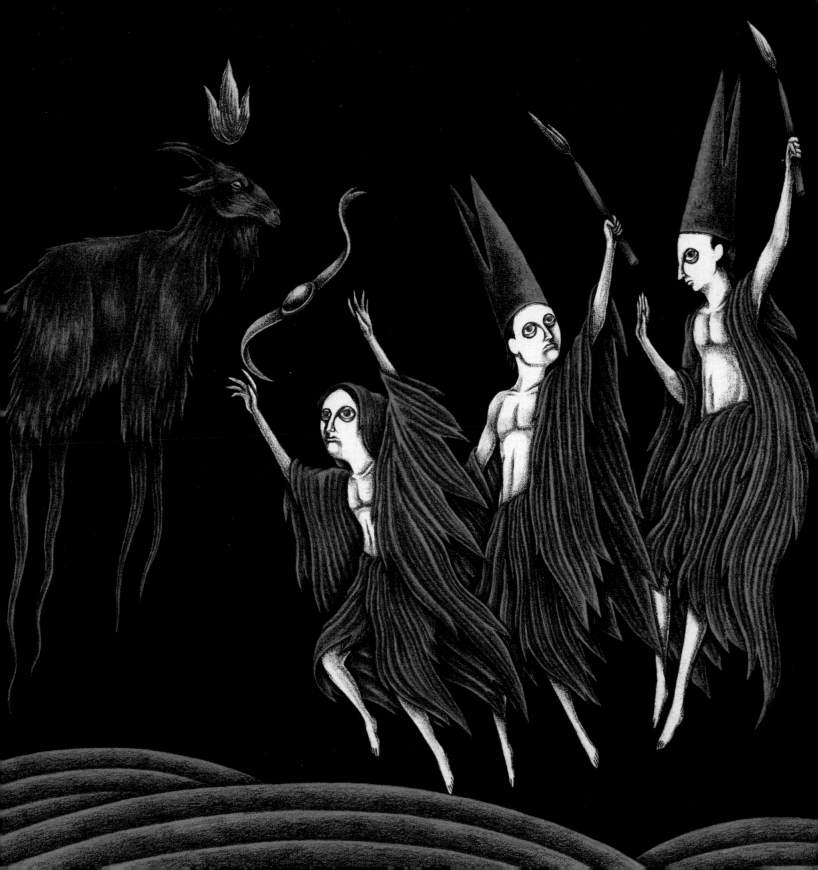

Olivier

A prince among the archangels, Olivier was summoned with long incantations at the sabbath.
Olivier seems to be one of the archangels even if his name is unknown. He is depicted as such: large
wings, a soldier's uniform, as well as a sword and a lance. Archangels are upper-level angels, directing
ordinary angels in their daily tasks.
Olivier is certainly a fallen archangel, brought down by Lucifer when he fell.

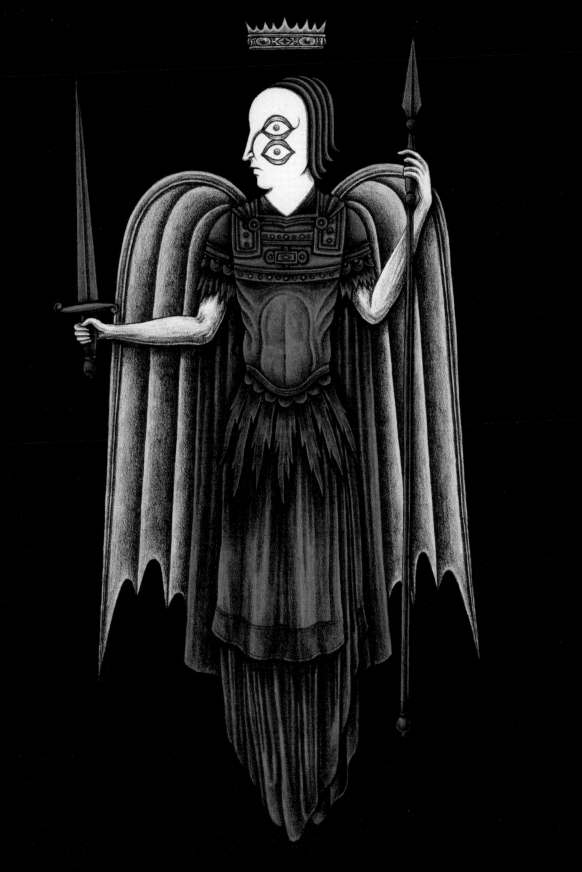

Orobas

A great prince in the infernal aristocracy, Orobas commands twenty legions.
He appears in the form of a powerful horse – both legs and head – but has the torso of a man,
demonstrating his mighty spirit.
Orobas is a master of time and can read the past and the present and foretell the future. He is
clairvoyant, detects lies, and can also reconcile enemies.

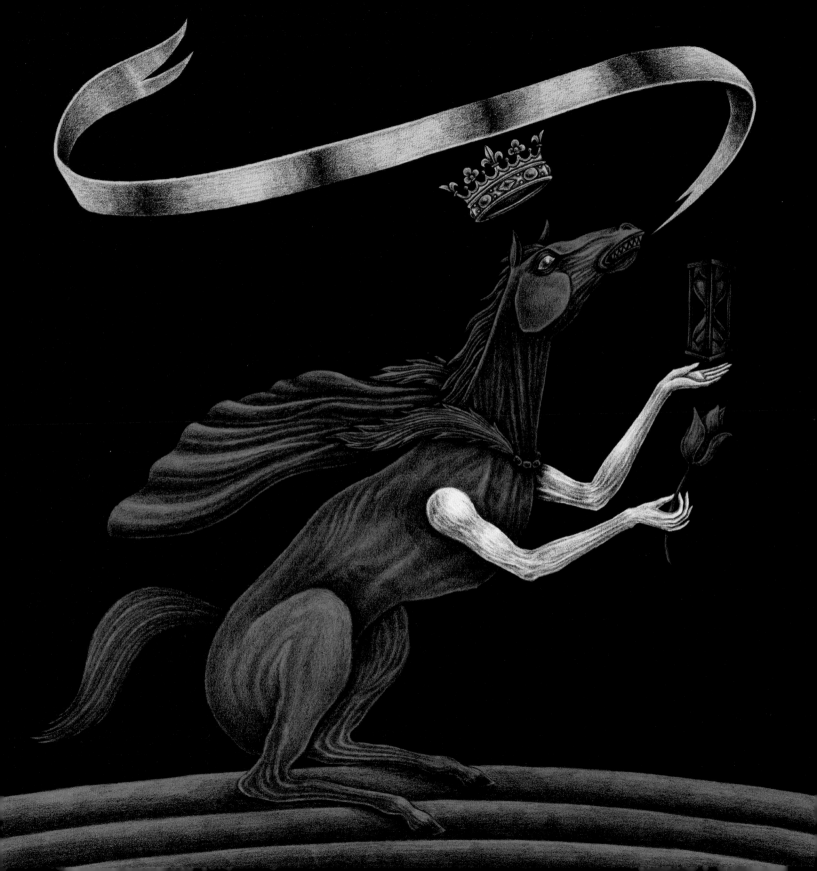

Phenex

Phenex is a grand marquis in Hell's aristocracy who appears in the form of a phoenix, a mythical
bird who is consumed in flames at death, and then reborn from the ashes. The demon Phenex has
the beautiful voice of a child when unseen but as soon as he is visible when summoned, his piercing
screams are unbearable for human ears. At the same time, he is well-versed in the sciences and a poet,
answering in rhyme when asked a question.
After a thousand years in Hell, he would like to return to Heaven amongst the angels.

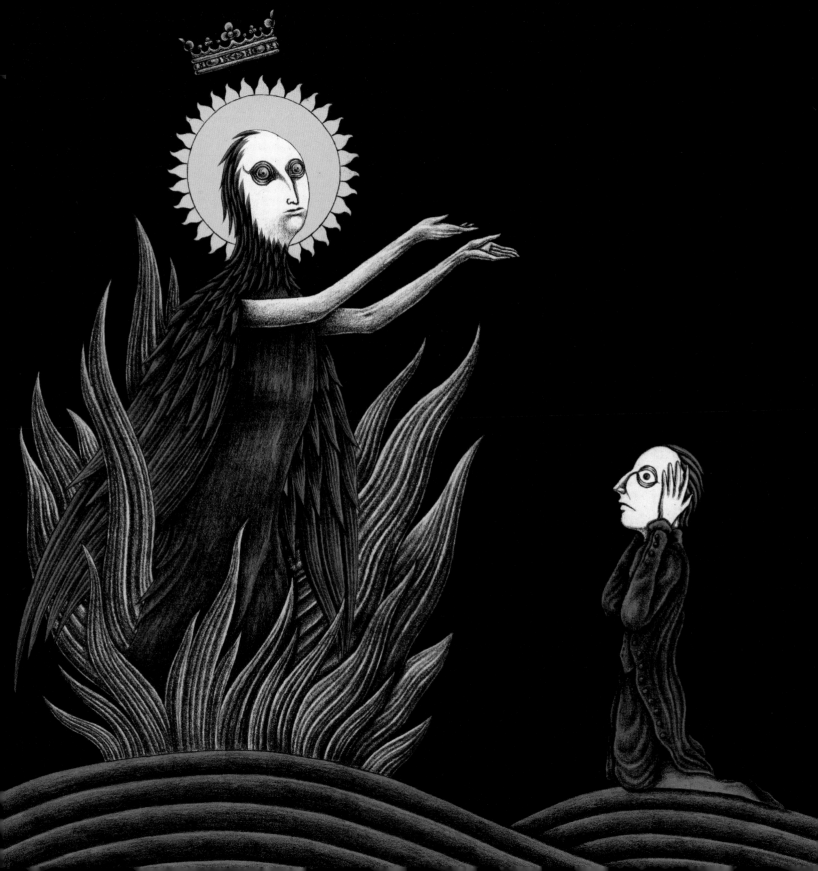

Piletski

A powerful Polish family. According to legend, when the girls of the Piletski family died they would be transformed into doves if unmarried and into moths if already married. In these new forms, they would announce their deaths to their parents.

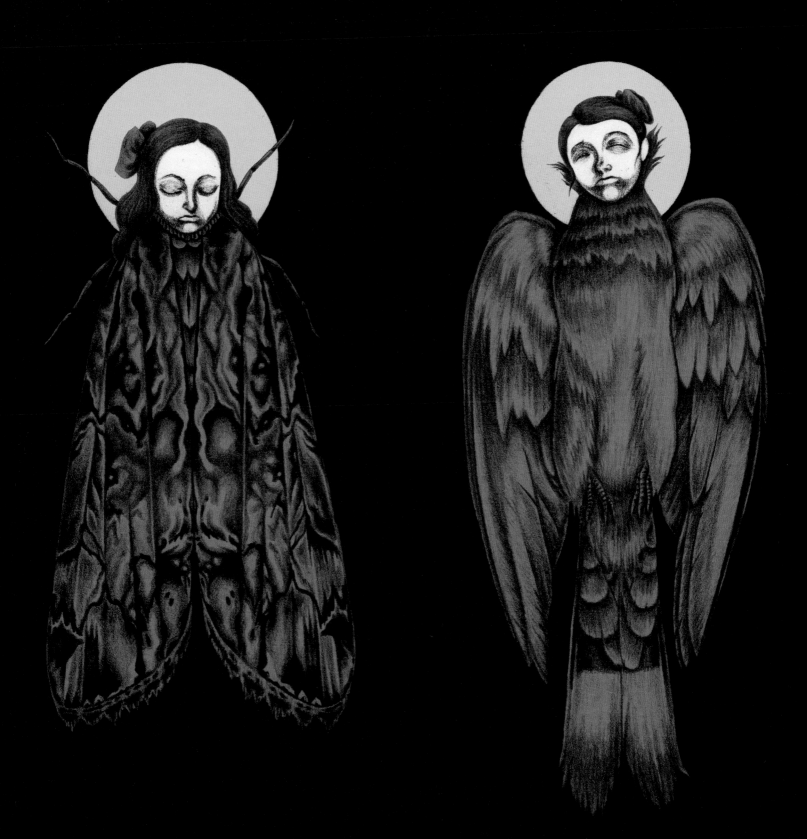

Puck

A popular demon, Puck has been called various names by different traditions in the Nordic and
Germanic cultures. He is often found in farms and monasteries, and can appear in the form of
a monkey clothed in a multicolor vest with bells. He is docile and complacent when treated well,
and will even help with daily tasks, but if he feels slighted he will become angry and capricious.
One of his demonic talents is to play a tune called "The Elf King's Jig." Anyone who hears the song
cannot stop from dancing, and the tables, chairs, and furniture break apart. The only way to stop
the dance is to play the tune in reverse or break all the strings of his instrument at one time.

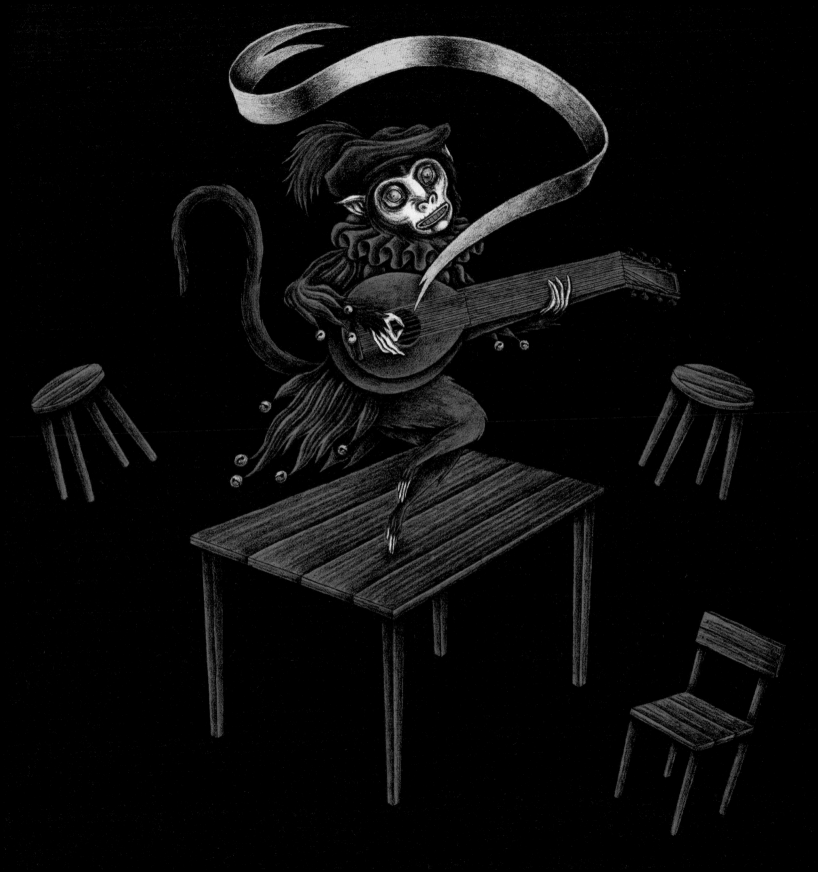

Purson

A great King in the infernal aristocracy, Purson commands 22 spirit legions. A man with the head
of a lion and riding a bear, he is heralded by the sound of trumpets.
Purson is a powerful, aerial demon. He can read the past and foretell the future, as well as read people's
thoughts. He wears an old-fashioned suit and carries an angry viper in his hand. He is honest, and his
clairvoyance enables him to rise to any occasion and discover all hidden things, even treasure.

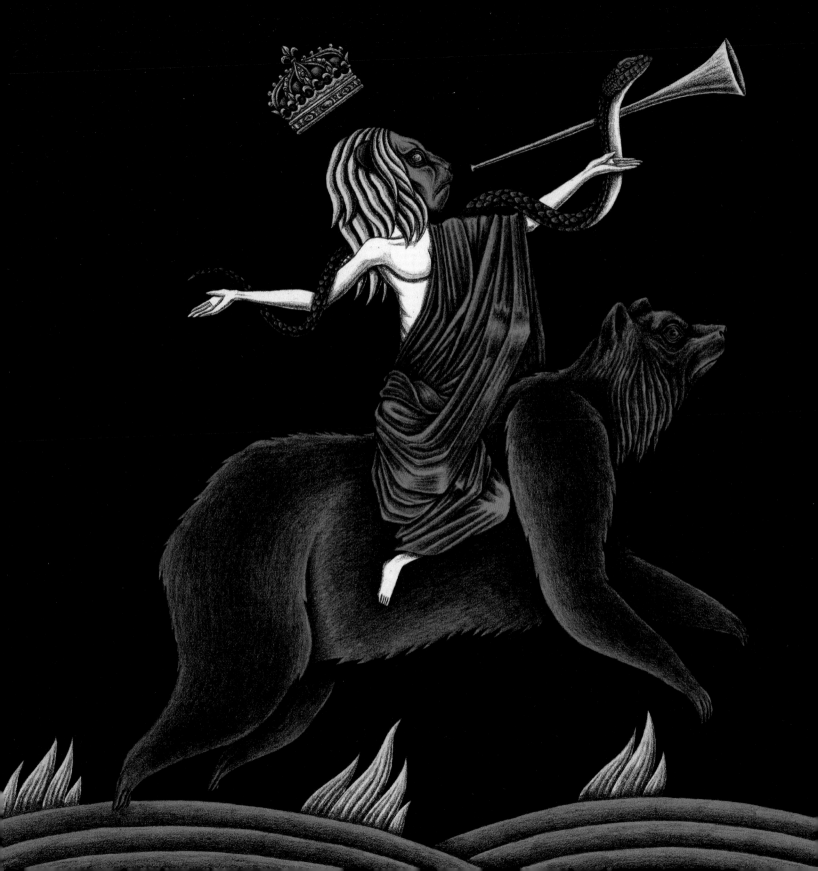

Raollet, Jaques

Jacques Raollet was a werewolf who, when called before the court, admitted to devouring women, windmills, wagons, lawyers, and even sergeants – the flesh of this last category he admitted was particularly difficult to digest.

Raollet was a vagrant with a terrible smell. His hair was long, his nails like claws and his expression was always sullen. He was condemned to death by the Angers court in the 16th century.

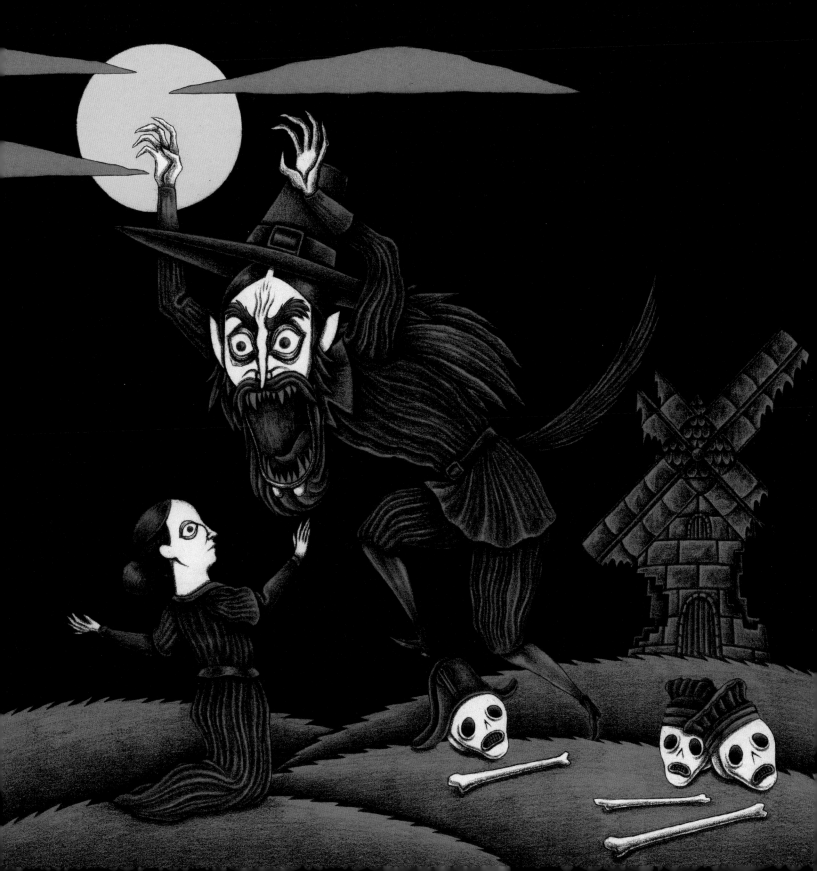

Raum

A powerful count in Hell's aristocracy and the commander of thirty legions.
He appears in the form of a raven and can destroy cities, as well as provide powerful dignitary positions for those he chooses.
Like Phenix he was a part of the Order of Thrones, the seventh choir in the celestial hierarchy, in charge of carrying the scales and the voice of God.

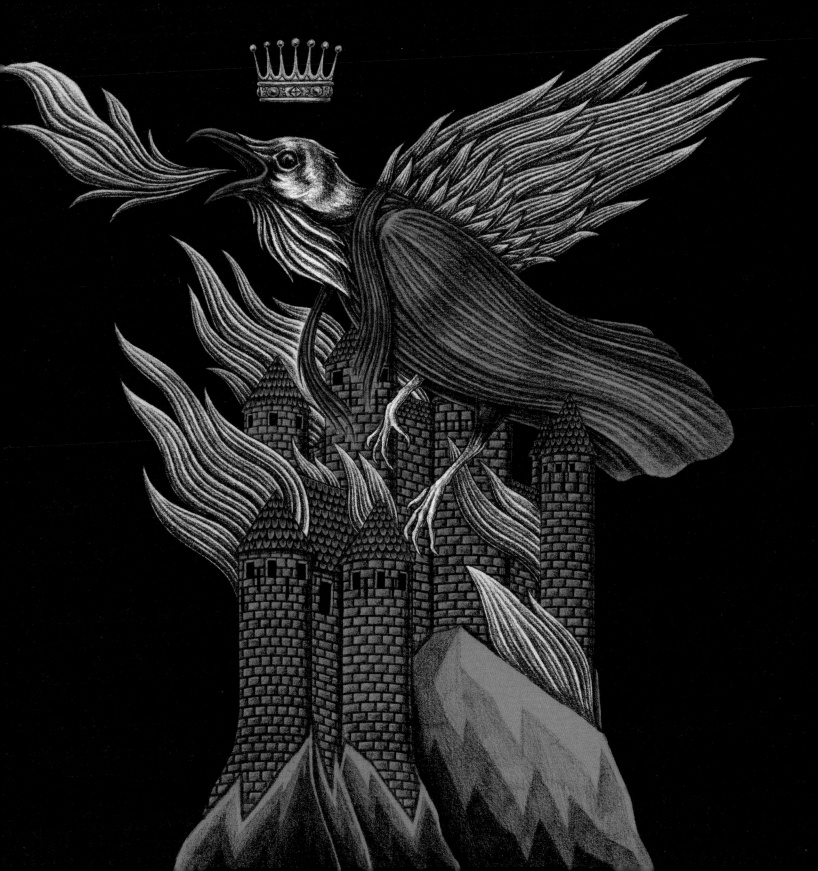

Rübezahl

A folkloric ghost from Silesia, Rübezahl controls the clouds and snow over mountains, shakes the valleys with violent winds, and creates storms. He has an incredible look: one leg from a sheep, the other from a bird, a lobster's claw, a wooden ivy-covered head, bells, and a knife and fork instead of ears! Rübezahl is a grotesque demon, made of odds and ends. His only demonic feature is his devil's fork tail.

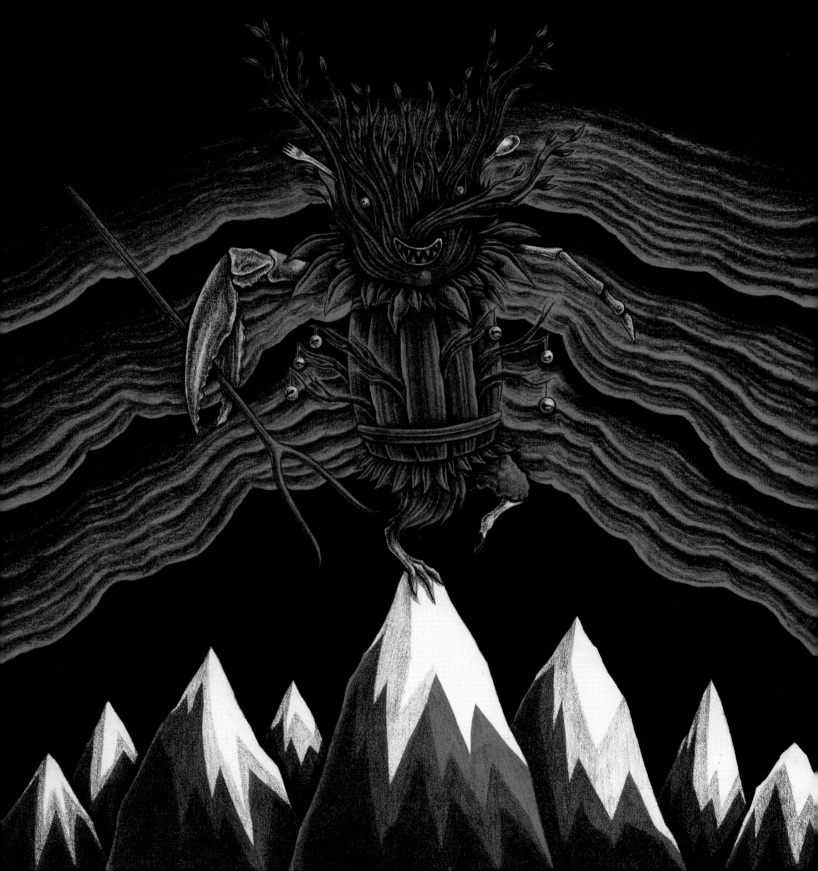

Satan

Depicted here in his most well-known form: horns, a goat's beard, pointed fawn ears, clawed feet, and the look of a blood-thirsty beast. But Satan is known for changing shape to better tempt his mortal prey, as seen in the story of the serpent in Genesis. He is Evil, the Prince of Darkness; nothing good can come from this creature.

When some of God's angels rebelled, Satan took the lead but was beaten by his creator and fell to Hell, where he has governed ever since. Satan means "enemy" in Hebrew, and as such is the demon who sows discord and the head of all other Hellish creatures. He is more than twelve kilometers high and as strong as a tower. His bat's wings are used as protection.

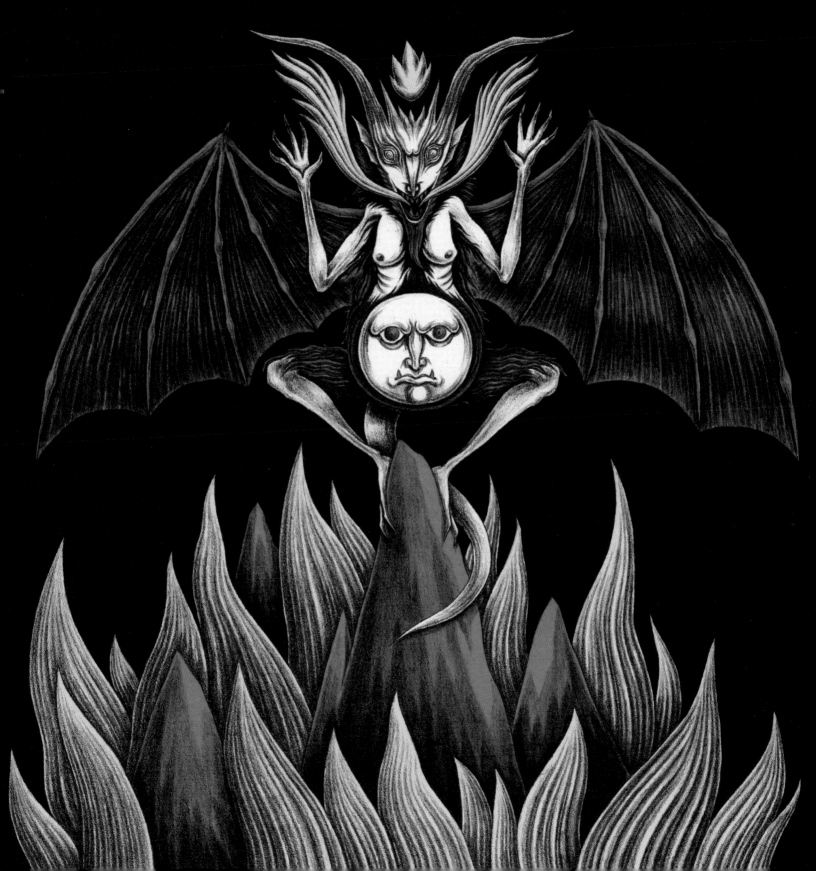

Secretain, Françoise

Françoise Secretain was a French witch who claimed to have seen the devil many times. The witch was known to have coupled with the demon in several of his forms – a cat, a dog, or a chicken. Françoise Secretain was condemned to be burned at the stake by the Franche-Comté court at the end of the 16th century but killed herself in her cell before she could be burned.

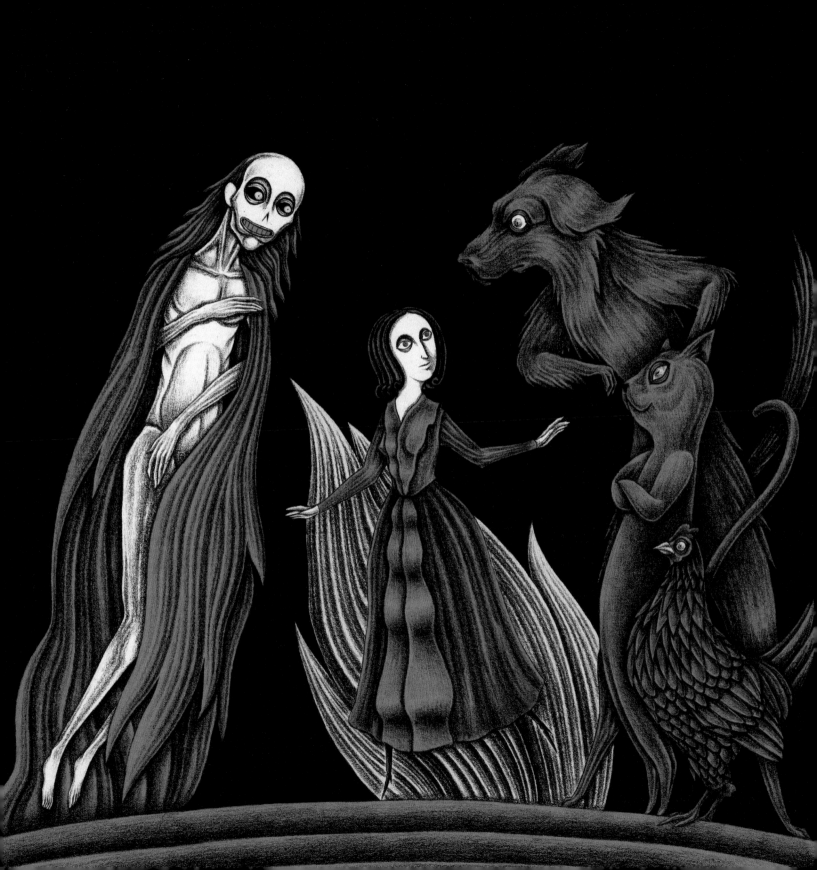

Sitri

Sitri is a powerful dark demon, and one of the princes in the infernal aristocracy. He is the Lord of deviant mischief-makers.

A lewd creature, he manipulates and arouses men's and women's passions. He forces men to remove their clothing and women to reveal their deepest secrets. He is a dangerous charmer and very seductive when in human form. However, he most often appears in his hybrid shape: the head of a leopard, the wings of a griffon, and the body of a man.

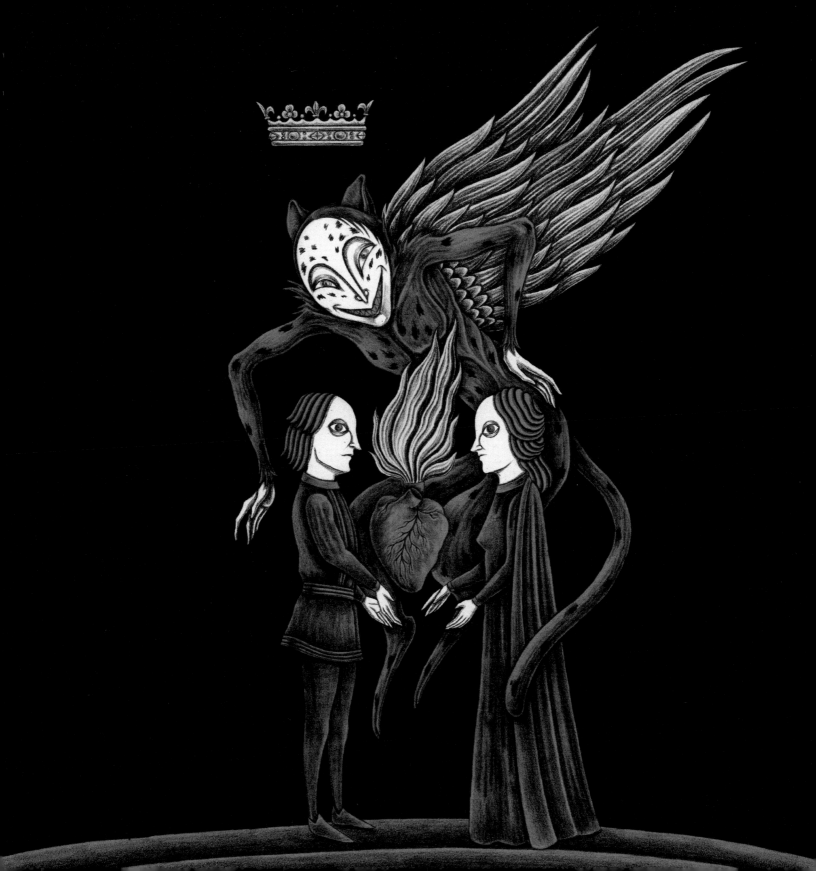

Stolas

A prince of Hell in the form of an owl, Stolas teaches astronomy and astrology. His expertise in plants and their uses, as well as his knowledge of minerals, makes him the ally of anyone who wishes to partake in rituals and magical incantations.
Stolas also comes to the rescue of thieves and bandits hoping to elude justice.

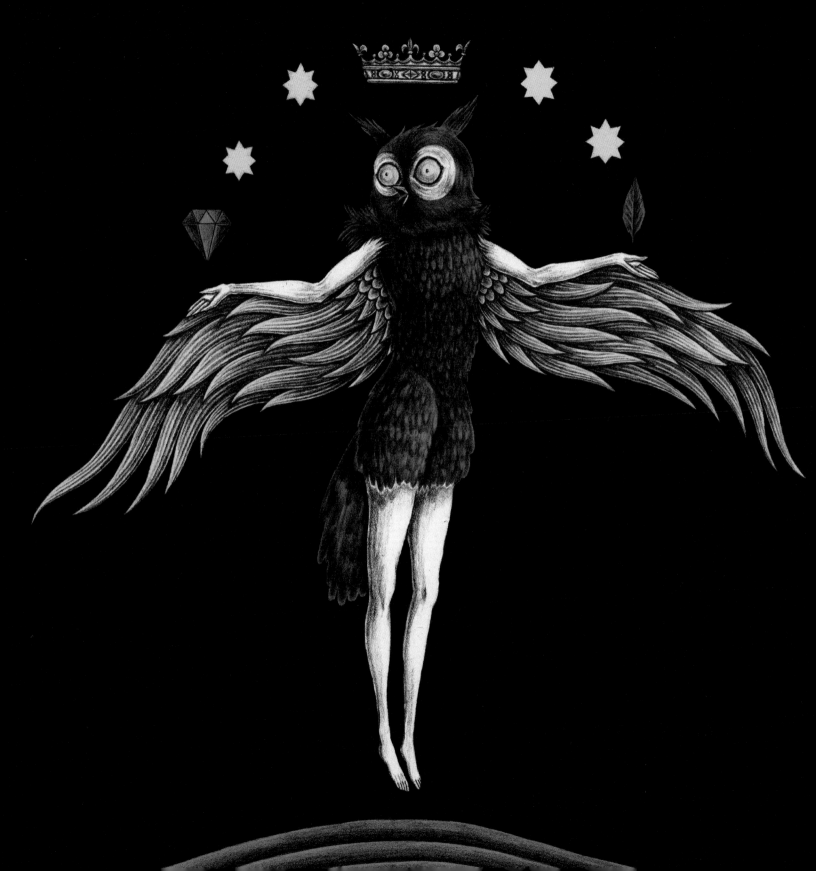

Tikbalang

Tikbalang is the name Filipinos give to the ghosts and spirits who live at the tops of trees. These beings have painted bodies and wide wings. Filipinos believe they can be detected by their strong, particular smell. The Tikbalangs are the spirits of the dead and are described as very large men with long hair and small feet.

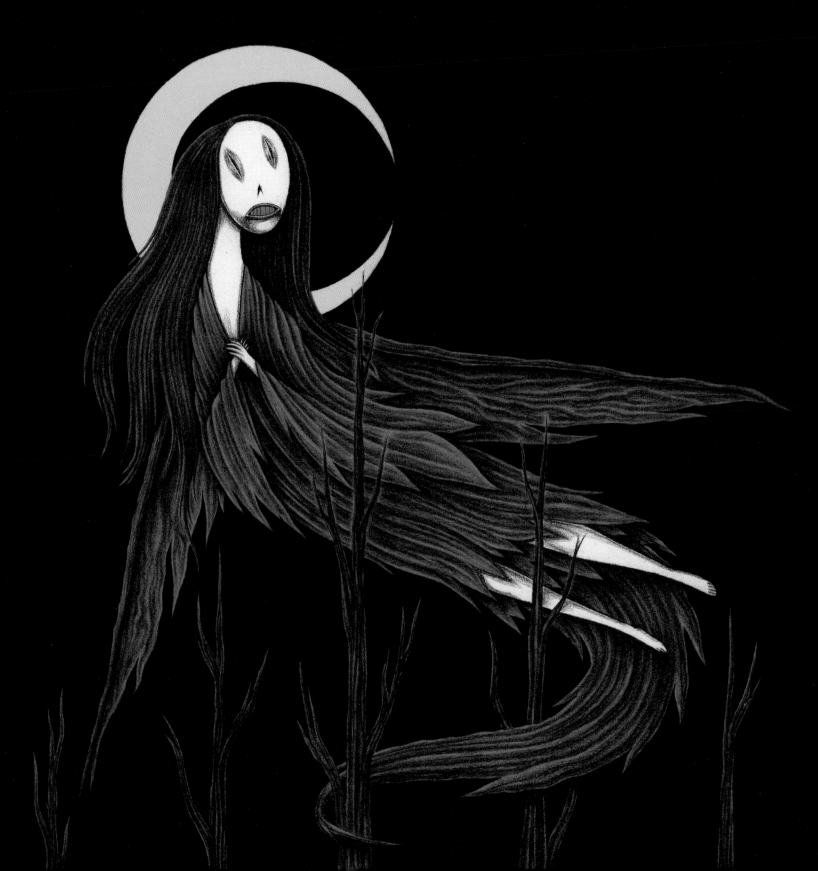

Uanna

A Mesopotamian deity and monster with the head and feet of a man but the body of a fish. His man's head, however, is hidden inside his fish's head.

Uanna was born, according to the Babylonians, of the primal egg from which all terrestrial things are born. He comes to land to teach, staying all day and speaking any language in order to instruct mankind in the arts, sciences, literature, and farming.

At night he returns to the waters of the sea.

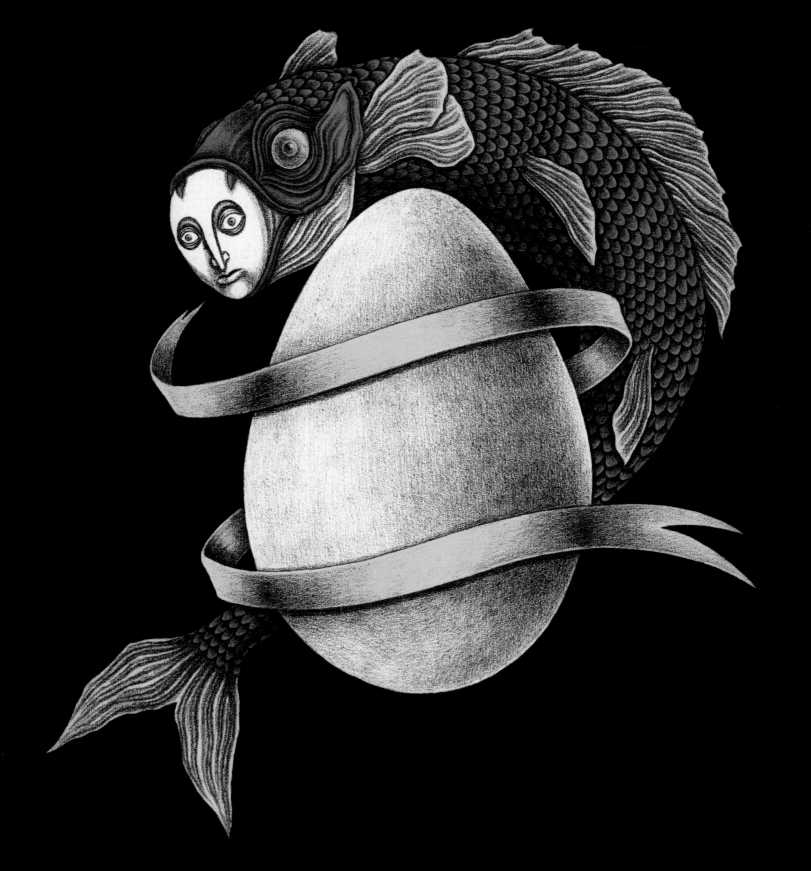

Ukobach

A lower-ranking demon with a burning, enflamed body. Ukobach has a grotesque head. Lucifer charges him with maintaining Hell's furnaces and he uses the oil coming from the bodies of the damned. He is the inventor of fireworks and deep-frying.

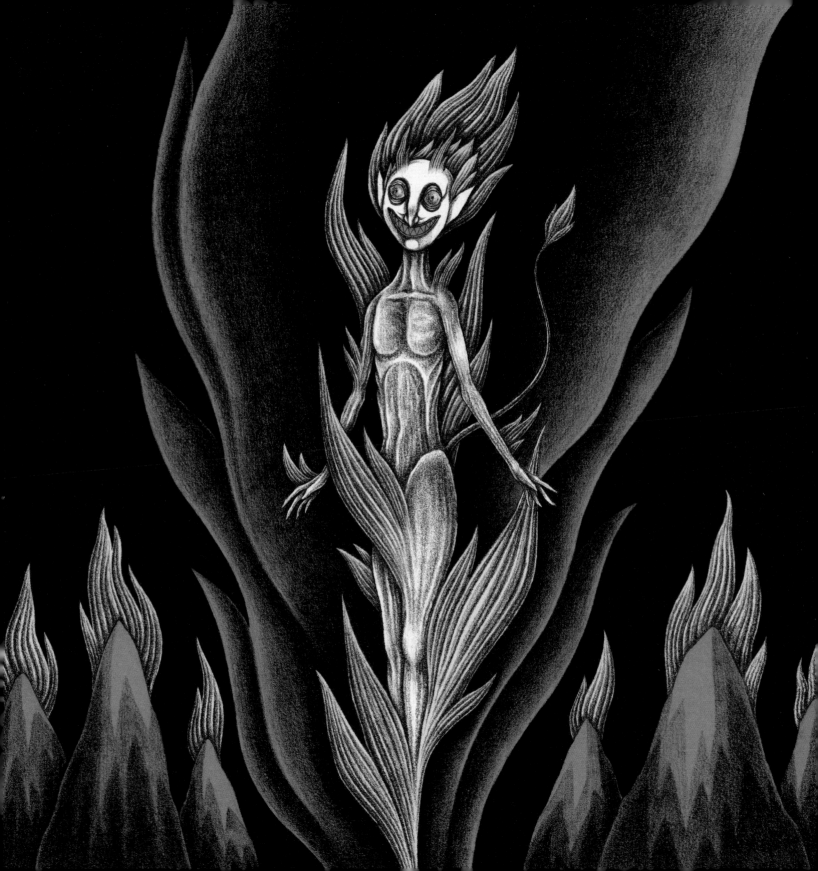

Valac

Valac is a half-angel, half-demon child who flies on the back of an impressive two-headed dragon. Valac looks like a cherub with wings. He is known for inducing lust and has a particular relationship with serpents, animals often associated with the libido. He commands 38 hellish legions and is a president of the underworld.

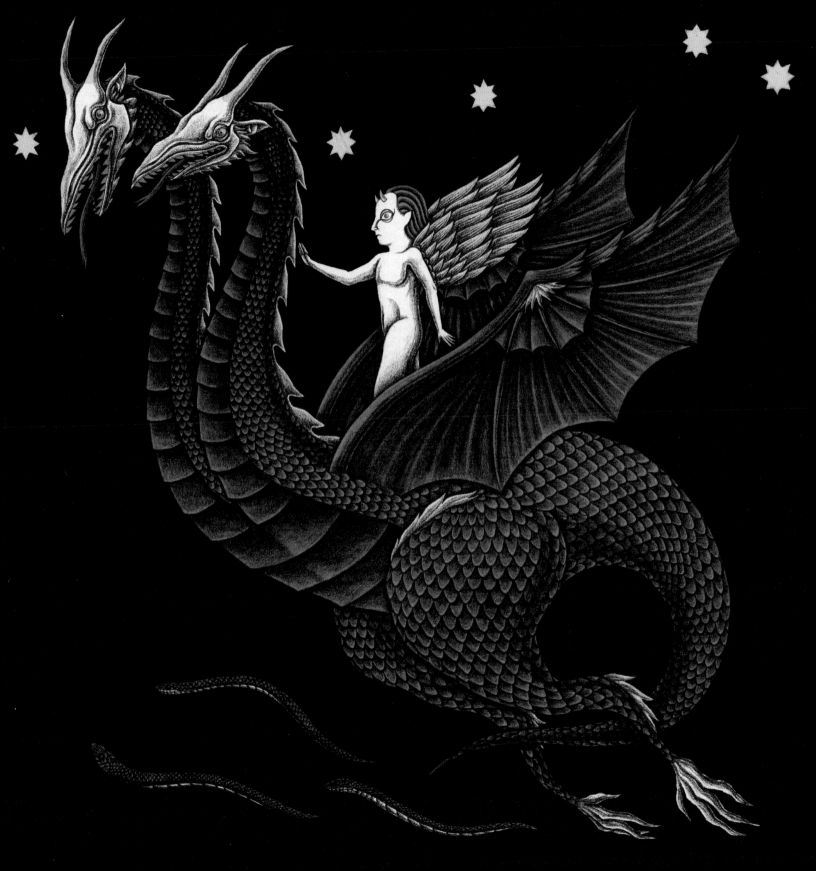

Valefar

Although he sometimes appears in angel form, Valefar is a powerful duke of the underworld. He may also appear with the head of a lion, goose feet, and the tail of a hare. He grants power to men by telling them the future and bestowing both genius and daring.

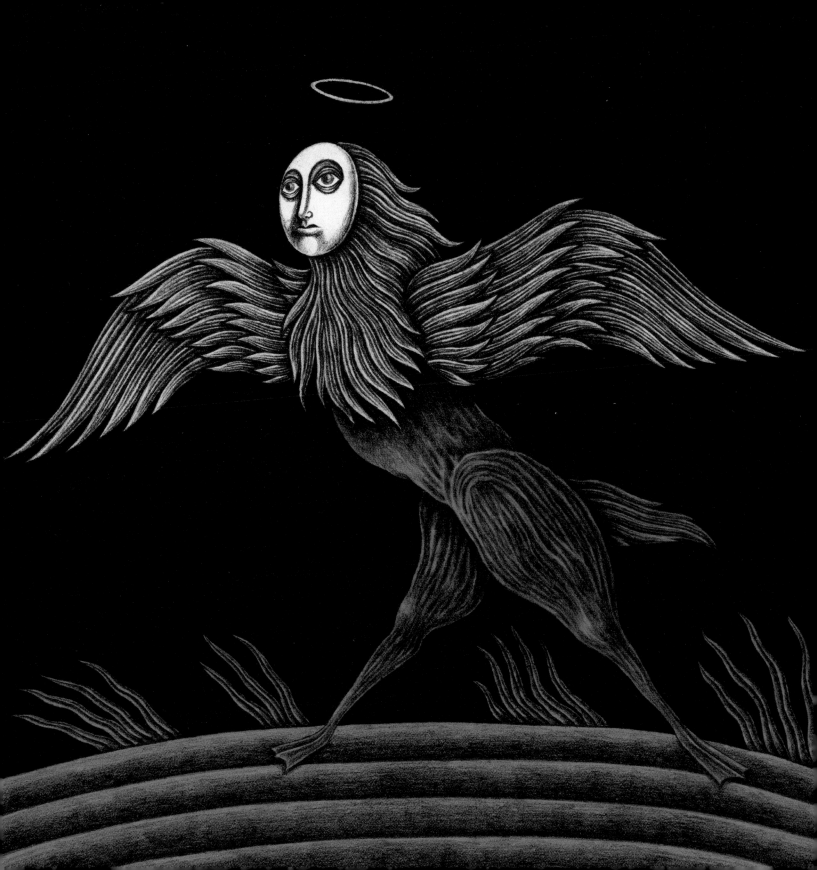

Vapula

Vapula is a grand duke in Hell's aristocracy and appears as a winged lion. Vapula is an expert in mechanics and philosophy. He pushes humans toward the sciences and guides the wise, but he also controls those who are rebellious and stubborn. Vapula commands 36 legions of unruly spirits.

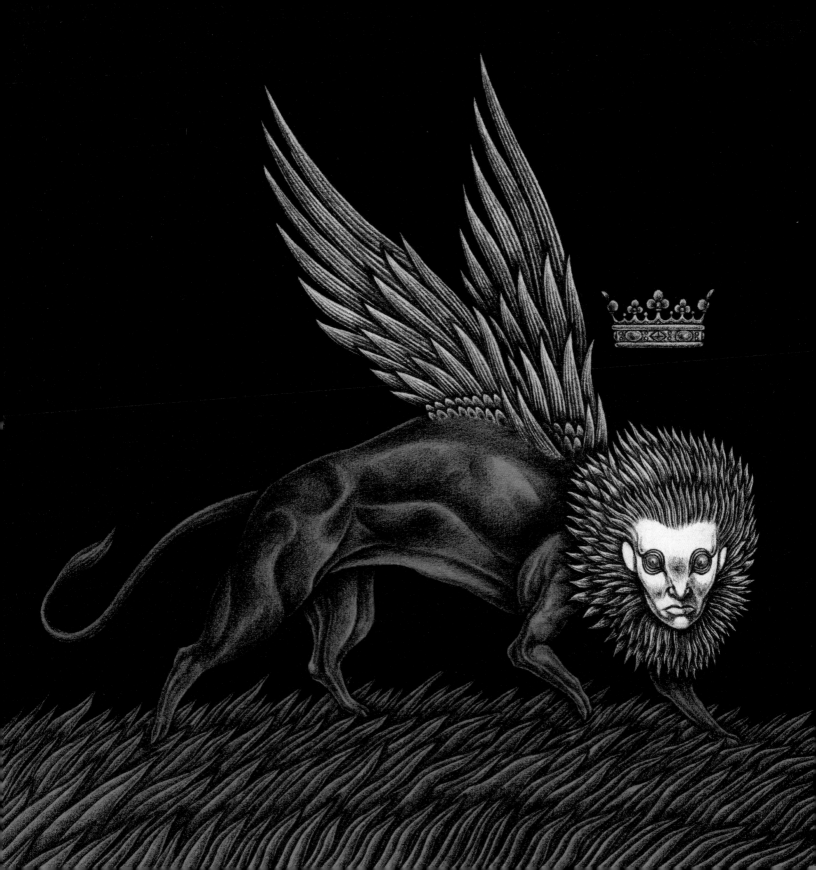

Vepar

Vepar is a demonic mermaid who enjoys capturing men and boats. She will then wound the men or give them incurable diseases. She will throw a boat into an abyss or force it to become lost at sea. She controls armies of ghost boats which will suddenly surface and disappear just as quickly as they appeared. A powerful duchess of the underworld, Vepar also commands the winds and storms.

156

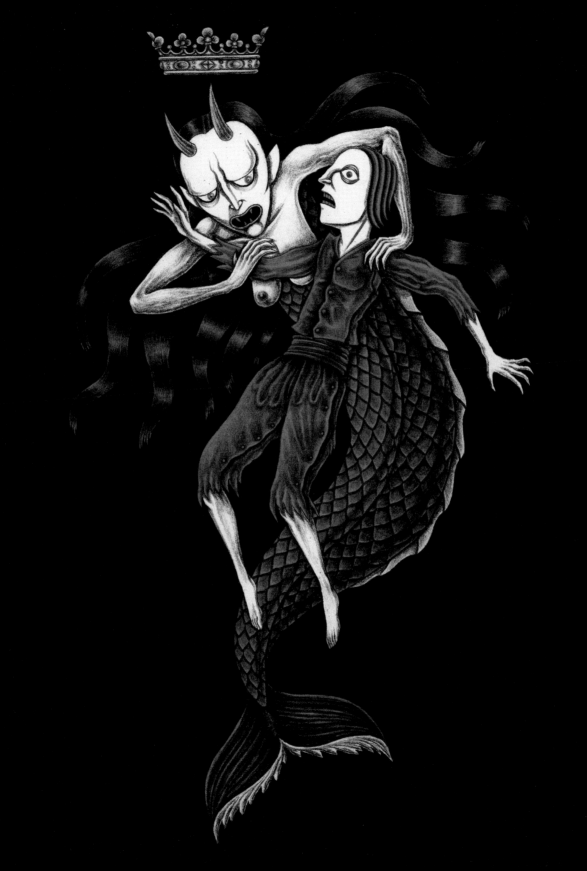

Vual

Vual takes the form of a powerful dromedary. He speaks Egyptian to humans. He can read the
past and the present and foretell the future. He commands 36 hellish legions. He is a powerful duke
in the infernal aristocracy who was once in the Order of the Powerful, the fourth order in the
Heavenly hierarchy.
Vual is a fallen angel who elicits the love and friendship of women and can speak all the languages
of the world.

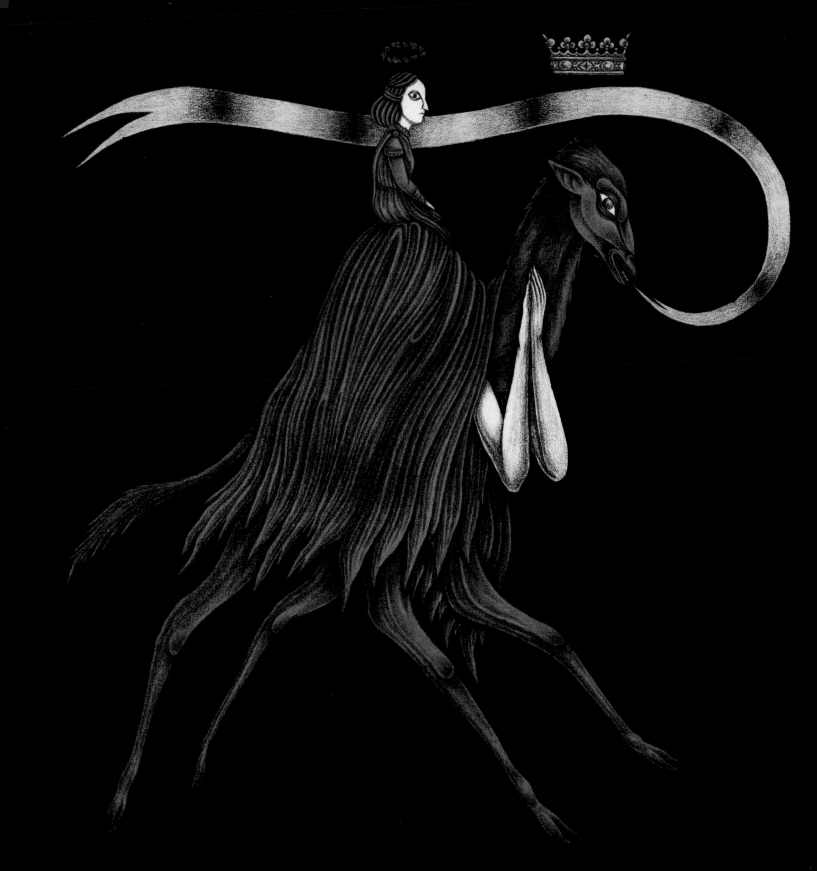

Yetzer-Tov, Yetzer-Hara

In the ancient Jewish tradition, the spirit world is divided in two: Yetzer-Tov rules over the spirits of light and Yetzer-Hara rules the world of shadows and demons. This dichotomy exists in most religions and relates to a balance in the world of the living.

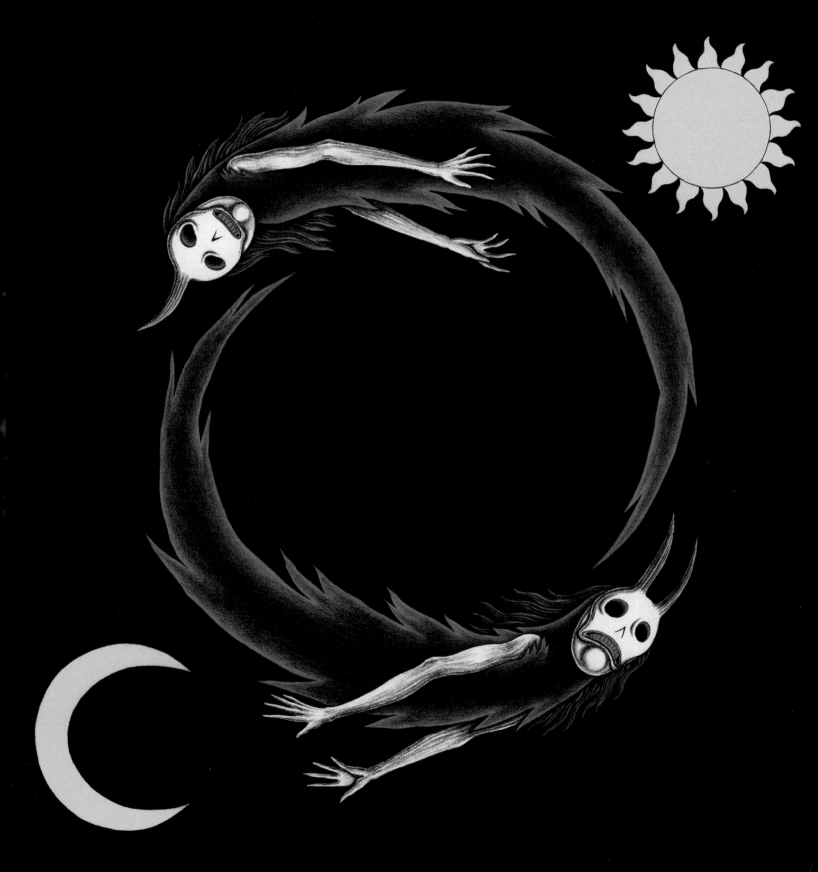

Zaebos

Wearing a crown decorated with eight jewels, Zaebos is an elegant duke of the underworld. He rides a crocodile and wears a horned helmet. He is known for his docile nature, but his crocodile is very dangerous – the animal is Zaebos's weapon and each night he swallows the sun to bring on the night and the shadows.

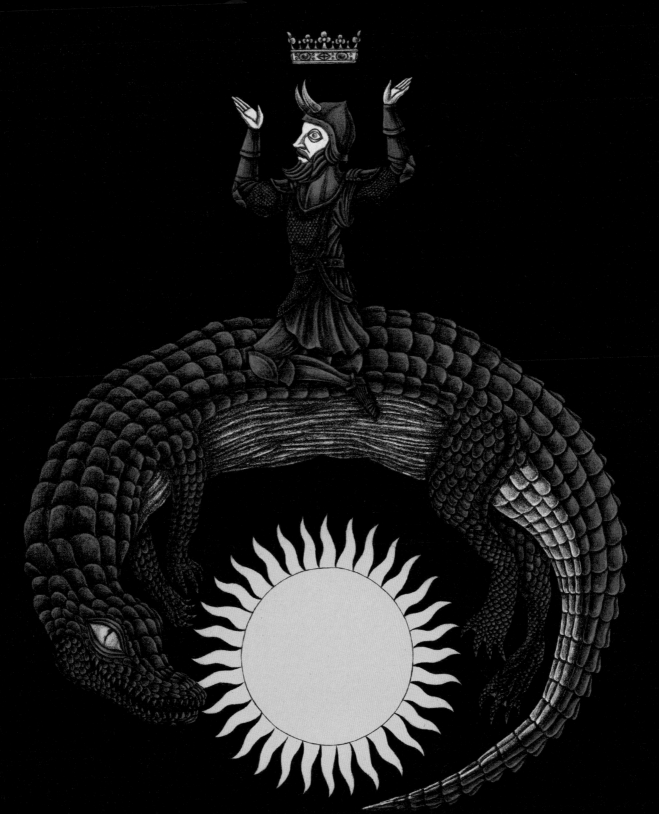

Zagan

A bull with the wings of a griffon, Zagan is a great king in Hell's aristocracy. He enjoys imitating Jesus and he transforms water into wine, blood into oil, a crazy man into a wise man, lead into silver, and copper into gold.
Zagan can take human form and he enjoys his libertine nature in this form: he enchants men to fall in love with one another and commands 33 legions of debauched and wicked spirits.

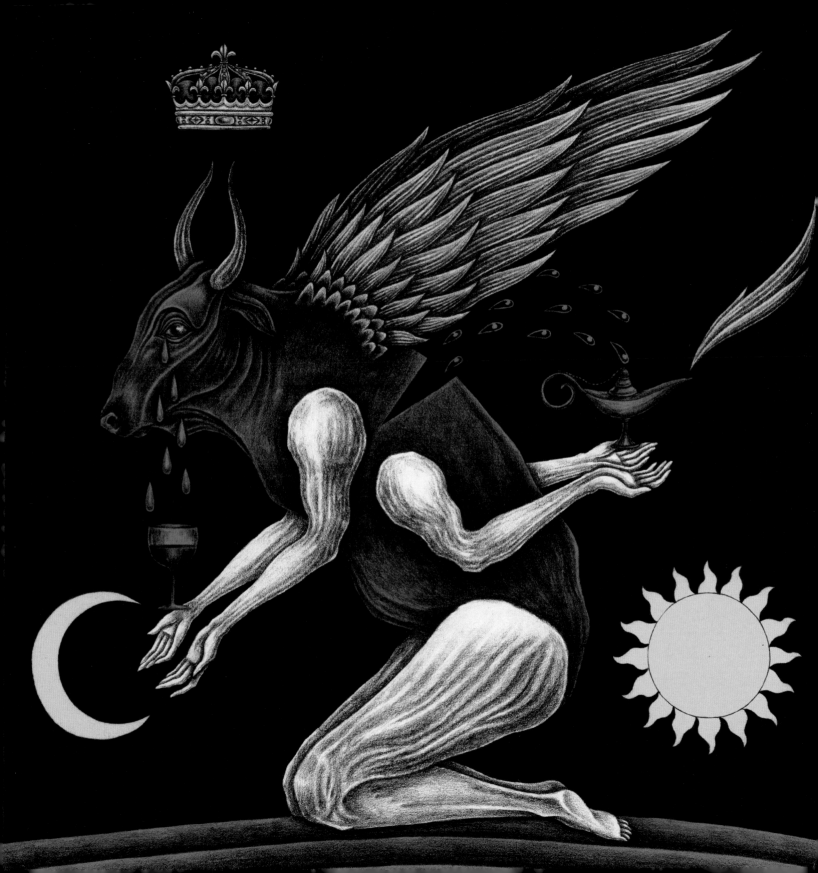

Postface

The Infernal Bestiary project began during a weekend in London in 2007. While walking around the Liverpool Street area with Justine, I came across an extraordinary and tiny bookstore whose name I completely forget. It was full of illustrated books, graphics, art, indie comics... The kind of place where I'm able to stay several days searching every shelf wondering what incredible books or authors I'm still about to discover.

And that's when I came across the book *Beasts!*, designed by Jacob Covey at Fantagraphics Books. I discovered a collection of illustrations where a multitude of talented artists each appropriated a creature from folklore around the world. The book was presented in an extremely neat edition! A huge slap and a revelation for my work.

The idea was beginning to take shape. I wanted to create my beasts. Without wanting to copy the original work, I wanted to make a bestiary and completely appropriate the universe. I still had to find a theme and a graphic way to deal with the subject...

Ten years later I discovered Jacques Collin's book *Le Dictionnaire Infernal*. This 1818 work lists all the knowledge of the time in demonology and superstitions, both folk and biblical. I had just found my common thread. Everything was beginning to come together: I was going to create a collection of illustrations with coherent graphics that would explore the underground and mythological world addressed in *Le Dictionnaire Infernal*.

It also seemed necessary to me to accompany my menagerie with texts, not to leave the reader frustrated by the lack of information. That's when I asked Justine to accompany me on the project. It was she who had already worked on the texts of the *Black Tarot*, our previous project.

There was one last step: find a publisher who understood my work and wanted to publish this kind of object. It was done with Gingko Press.

I would like to thank Torben Körschkes, Anika Heusermann, David Lopes and the whole team at Gingko Press for making sure that you could hold this book in your hands!

I am really very happy that this long work has been successful and that this collaboration has been so fruitful! I hope you will enjoy the book as much as I enjoyed it!

Matthieu Hackière

Matthieu Hackière is an artist and illustrator. Works published include *Macchabée Strips* (Ankama Éditions, 2010), *Le tarot noir, imagerie médiévale populaire* with Justine Ternel (Editions Tredaniel/vega éditions, 2013) and *Joséphine la chauve-souris* also with Justine Ternel (Auto-édition, 2016). Justine Ternel has worked for different festivals in England and took a course in anthropology. She and Matthieu met twelve years ago and share a passion for books.
They live and work in Lille, France.

The Infernal Bestiary

First published in April 2019 by Gingko Press

Gingko Press Inc.
2332 Fourth Street, Suite E
Berkeley, CA 94710, USA
Phone: +1 (510) 898 1195
books@gingkopress.com
http://gingkopress.com

Gingko Press Verlags GmbH
Schulterblatt 58
20357 Hamburg, Germany
Phone: +49 (0)40 291 425
gingkopress@t-online.de

Printed in Serbia by Publikum.

Text: Justine Ternel
Translation from French: Michelle Bailat-Jones
Editorial: Jason Buchholz
Layout and Design: Torben Körschkes

ISBN: 978-1-58423-701-3